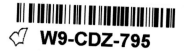
IN FOCUS

DOROTHEA LANGE

PHOTOGRAPHS

from

THE J. PAUL GETTY MUSEUM

Judith Keller

The J. Paul Getty Museum

Los Angeles

In Focus
Photographs from the J. Paul Getty Museum
Weston Naef, *General Editor*

Getty Publications
1200 Getty Center Drive
Suite 500
Los Angeles, CA 90049-1682
www.getty.edu

© 2002 J. Paul Getty Trust

Christopher Hudson, *Publisher*
Mark Greenberg, *Editor in Chief*

Library of Congress Cataloging-in-Publication Data

Keller, Judith.
 Dorothea Lange : photographs from the J. Paul
Getty Museum / by Judith Keller.
 p. cm. — (In focus)
 ISBN 0-89236-675-3 (pbk.)
 1. Photography, Artistic. 2. Lange, Dorothea.
 3. J. Paul Getty Museum—Photograph collections.
 4. Photograph collections—California—Los Angeles.
 I. Lange, Dorothea. II. J. Paul Getty Museum.
 III. Title. IV. In focus (J. Paul Getty Museum)
 TR653.K45696 2002
 770'.92—dc21 2002007290

Contents

Foreword

The principal goal of the In Focus series is to make available in handsome and affordable publications the photographs collection of the J. Paul Getty Museum. It is particularly fortunate when the institution can feature the work of California artists, as was the case with the 1997 installment on Carleton Watkins and now applies to the present book on Dorothea Lange. This volume is especially timely, for the issues Lange documented in California during the 1930s and 1940s are current concerns in the state even today. The effects of economic upheavals, the plight of migrant workers, and the need for internal security are reminiscent of the labor union struggles, dust bowl refugees, and interned Japanese Americans of Lange's day.

The photographer's life and art were discussed in a colloquium at the Getty Museum on July 27, 2001, which provided part of the text for this book. The participants included Keith Davis, Therese Heyman, Judith Keller, Weston Naef, Sally A. Stein, and Michael Williamson as well as David Featherstone, the moderator of the colloquium and editor of its transcript. I would like to thank these individuals for their contributions, particu-larly Ms. Keller, who wrote the introduction and texts accompanying the plates, and Mr. Naef, whose idea the In Focus series was and under whose stewardship the Lange collec-tion at the museum has grown significantly.

There are many other staff members, in addition to those listed on the last page of this book, who deserve recognition, includ-ing Lisa Henry and Lynne Kaneshiro, who assisted with the accompanying exhibition, and Amy Armstrong, Julian Cox, Marc Harn-ly, Ernie Mack, Erin Murphy, Marisa Nuccio, Ted Panken, and Rebecca Vera-Martinez. A consultant, Valerie Baas, aided our conser-vators in treating the photographs for publi-cation and exhibition. I would also like to thank Ms. Heyman and her colleagues Drew Johnson and William McMorris at the Oak-land Museum of California for aiding Ms. Keller in her research. Special acknowledg-ment goes to members of Lange's family— Helen, John, and Leslie Dixon—who shared their reminiscences and archives with us.

Deborah Gribbon
Director, The J. Paul Getty Museum
Vice President, The J. Paul Getty Trust

Introduction

In the popular imagination, Dorothea Lange (American, 1895–1965) is a famous woman. As a photographer, she has nearly the name recognition of Ansel Adams, her San Francisco colleague. As a female artist, she is as renowned as the painters Mary Cassatt, Georgia O'Keeffe, and Frida Kahlo. As a cultural figure representing the Great Depression, she joins icons like Franklin Delano Roosevelt, John Steinbeck, and Woody Guthrie. Her best-known work, *Migrant Mother* (pl. 13), was even made into a U.S. postage stamp in 1998. How did this ex–New Yorker, born in the nineteenth century and raised in confusing, often unhappy, circumstances, become an independent woman, an artist, and an activist?

Lange's New Jersey childhood involved a case of polio, which left her with a malformed right foot, a slight limp, and a self-conscious nature. In her adolescent years, her father, Henry Nutzhorn, disappeared. He had been a lawyer, but something caused him to need to escape. She would not talk about the reason, or about him, to anyone. She and her brother and mother then moved in with her hard-drinking German grandmother and great-aunt, and her mother, Joanna Lange Nutzhorn, went to work, first for the public library and then the juvenile court. Dorothea commuted to school, attending P.S. 62 on Manhattan's Lower East Side and Wadleigh High School for Girls on the Upper East Side.

After high school, following middle-class expectations, Lange took courses at the New York Training School for Teachers. However, she had already determined that she wanted to be a portrait photographer and worked part-time for

one of the best, Arnold Genthe, who had come to New York from San Francisco. He encouraged her photographic study with Clarence H. White at Columbia University and may have suggested that she try to see more of the world. She left New York with a friend in 1918, intending to travel overseas while plying her trade, but was stalled by theft in San Francisco. A local businessman lent her his patronage, and she opened a portrait studio on Sutter Street. In 1920, her business a success with the wealthy of San Francisco, she married Maynard Dixon, an artist/illustrator twenty years her senior. After their wedding, Dixon cut back his hours in advertising design, made lengthy sketching trips, and devoted more time to painting while Lange's studio provided income. Later in the decade they had two sons three years apart.

The Great Depression arrived with the early 1930s, creating an atmosphere of uncertainty and reducing commissions for both Lange and Dixon. They, like other bohemians of the era, decided to drop out for a while by taking up residence in rural Ranchos de Taos, New Mexico. Mabel Dodge Luhan, the originator of the idea of Taos as an artists' mecca, provided a studio for Dixon. Lange, although there primarily as a mother and housewife, managed to make informal studies of the Taos Indians, photograph dances at the pueblo, and casually capture aspects of her temporary neighborhood. It was a productive and momentarily secure period for the family.

They stayed seven months but finally returned to San Francisco and the realities of maintaining a household and their careers in hard times. Lange and Dixon decided to give up their home and live apart, in their respective studios. Their two boys had already been sent for boarding in nearby Watsonville. For the first time in more than a decade, Lange was on her own. She was a mature woman in her thirties; she had been the breadwinner for nearly fifteen years. And she was sensitive to the world around her, perhaps from her girlhood wanderings at the extremes of Manhattan, perhaps from her more recent sojourn in the Southwest and a friendship with the champion of Indian rights, John Collier, Sr., or perhaps because the world around her was then in perpetual upheaval.

In 1932 Franklin Delano Roosevelt was elected president, the first Democrat voted into that office in sixteen years. He was inaugurated in March 1933 and immediately began his New Deal to benefit the "forgotten man." This included the

Unknown Photographer.
Untitled (Portrait of Dorothea Lange), spring 1937.
Gelatin silver print, 13.7 × 16.7 cm (5⅛ × 6⁹⁄₁₆ in.).
Gift of the Dixon Family, 2000.55.2.

National Industrial Recovery Act, legislation that guaranteed workers the right to organize and engage in collective bargaining. Union busting was now officially against the law. In California, the Socialist author Upton Sinclair ran for governor on his End Poverty In California plan and nearly won. In New York, the Communist artist Diego Rivera, after completing murals in San Francisco and Detroit, was at work on *Man at the Crossroads*, which included a portrait of Lenin; his patrons, the Rockefellers, disapproved. Artists and intellectuals from both coasts lined up behind the falsely convicted labor organizer Tom Mooney with a petition to gain his pardon from San Quentin.

Change was in the air, news was part of life, reportage was art. In California, where labor had always been restless, word of strikes, in the city and in the fields, became commonplace. The struggles between organizers, workers, and employers culminated in the general strike of July 1934. This action, which paralyzed San Francisco as well as shipping along the entire West Coast, began as a maritime strike called by the International Longshoremen's Association on the Embarcadero. A massive labor march was staged, the governor declared a state of emergency, and the National Guard was deployed. The drama of San Francisco labor was national news. In the spring and summer of 1934, a public art commission for the city also received attention.

At the suggestion of the social realist artist George Biddle, President Roosevelt had instituted another aspect of the New Deal in late 1933: the Public Works of Art Project. In January 1934 twenty-six artists were hired to create paintings on the theme "Aspects of Life in California" for the city's newly constructed Coit Tower to initiate this federal program. The murals became a controversial topic when the press discovered references to Communism in the iconography. Publicity of the "Red Scare" variety kept the tower in the public eye, but closed to the public, until October. However, Lange, a member of the arts community through her husband, no doubt saw the wall-sized scenes of agricultural and industrial life long before the official unveiling.

Also in 1934, diverging from her studio portraits for hire, Lange exhibited photographs of labor leaders, May Day demonstrators, and breadline recipients in her first one-person show, at the studio of a friend, Willard Van Dyke. While it was on view, Lange met Paul Taylor, a scholar of agricultural labor at the University

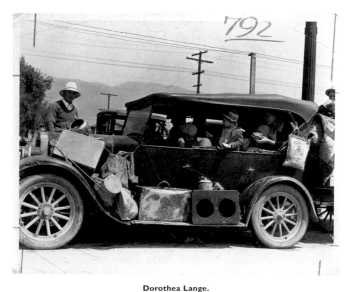

Dorothea Lange.
Dust Bowl Refugees Reach a "Promised Land"—California, 1936. Gelatin silver print,
image: 17.6 × 24.3 cm (6¹⁵⁄₁₆ × 9⁹⁄₁₆ in.); sheet: 20.5 × 25.4 cm (8¹⁄₁₆ × 10 in.). 2001.51.2.
This print was published in the *New York Times* on July 5, 1936,
with the caption "A Family Unit in the Flight from Drought."

of California, Berkeley. In September, one of her new social documentary images ran simultaneously with one of his articles in the social welfare monthly *Survey Graphic.* This began a new partnership in Lange's life and work.

Lange and Dixon divorced in 1935; she married Taylor late that year. They worked together in a pursuit that joined science and art and made a difference in the lives of many victims of the depression. Lange was forty years old and had finally found her voice. She would use it for both art and activism.

Although Lange's work is often referred to as documentary or social documentary photography, her biographer, the late Henry Mayer, also described it as public photography. She was in the employ of various federal agencies from 1935 to 1945, and the thousands of pictures she made for the Resettlement Administration (RA), the Farm Security Administration (FSA), the Bureau of Agricultural Economics (BAE), the War Relocation Authority (WRA), and the Office of War Information (OWI) are in the public domain. Appropriately, the surviving

negatives and prints are now housed in the Prints and Drawings Division of the Library of Congress and in the National Archives. Another public institution, the Oakland Museum of California, preserves that part of her legacy donated by Taylor after her death. It includes about 25,000 negatives and 6,000 prints as well as correspondence, journals, and maquettes.

The Getty Museum collection of Lange's pictures began as a holding of only 7 works acquired in 1984 when the Department of Photographs was established. In 1998 the museum was able to obtain at auction a rare, early, inscribed print of *Migrant Mother*. This purchase led to communication with the photographer's heirs, and the collection grew significantly as a result. It now contains 124 pictures, among them a group of Lange's little-seen New Mexico photographs of 1931; 15 RA/FSA images issued in the mid to late 1930s; several Masonite-mounted works that were exhibited at the Museum of Modern Art, New York, in 1952; a selection of fine prints, made with the assistance of Ansel Adams, from the Utah plates she produced for *Life* in 1953; and a notable group of images created during her months in Asia in 1958.

Lange's style of compassionate documentary photography is still relevant and very much alive in the work of current artists such as Mary Ellen Mark, Gilles Peress, and Sebastião Salgado. However, as Lange herself lamented in the 1950s, the federal patronage that encouraged so much of her labor is gone. She turned to the picture magazines for support, as did her successors. Documentarians became photojournalists chronicling special stories in their own distinctive styles. But *Look* ceased publication in 1971, and *Life* stopped weekly issues in 1972. Now even the independent agencies assembled by photographers themselves to better market their images are threatened by the advent of digital/on-line technology and a new kind of management that seeks only to add to picture archives for Internet sales. Exceptional documentary essays come more and more from a personal passion and are seen mainly in galleries and museums rather than by the wider public in the mass media, bringing us full circle to Lange's first days of photographing in the streets of San Francisco.

Judith Keller
Associate Curator, Department of Photographs

Plates

Note to the Reader

Multiple titles are given for a number
of the photographs, reflecting Lange's titles
and/or inscriptions and published titles.

During her career Lange often supervised
a printing assistant. However, in the
1930s many of the negatives she produced
for the Resettlement Administration/Farm
Security Administration were printed at
the agency's Washington, D.C., laboratory
(for example, pls. 10–12 and 20). Some of
the Utah images she created for *Life* in
1953 (pls. 30–33 and p. 144) were printed
with the assistance of Ansel Adams.

PLATE I

Maynard Dixon and His First Son, Daniel

1925

Gelatin silver print
13.8 × 10.8 cm
(5 $\frac{7}{16}$ × 4 $\frac{1}{4}$ in.)
2000.50.1

Maynard Dixon was fifty years old when Lange, almost thirty, gave birth to their first child, Daniel (another son was to follow three years later). Dixon, born in Fresno to a ranch-owning family, had been married previously and had a daughter of fifteen. He had decided on a career as an illustrator in his teens and had studied briefly at the California School of Design in San Francisco. Before the age of twenty he was producing pictures for the *Overland Monthly* and soon started working for the *San Francisco Morning Call.* Charles Lummis, the Los Angeles writer, publisher, and founder of the Southwest Museum, met Dixon in 1898 and encouraged him to investigate New Mexico and Arizona for artistic material. With Lummis as his mentor, Dixon got to know the reservations and trading posts of those states; his drawings and paintings were published in the *Land of Sunshine* magazine, Lummis's vehicle for promoting the Southwest.

The 1906 San Francisco earthquake destroyed Dixon's studio. The next year he left for New York, where his Western views were a success in the publishing world but where he felt his vision was being compromised. In 1912, returning to San Francisco and a studio on Montgomery Street, he pursued public and private mural commissions, exhibited his easel paintings, and, in 1916, went to work designing billboards and other advertising pieces for the firm of Foster and Kleiser. Dixon's twelve-year marriage to Lillian West Tobey ended in divorce in 1917. He met Lange at her portrait studio in the back of the Hill Tollerton Print Room in 1919.

This well-dressed, well-connected, well-established San Francisco artist was, no doubt, a fascinating, even exotic, personality to the young, newly arrived New Yorker. An anti-intellectual outdoorsman, Dixon nonetheless wrote poetry, knew writers as well as painters, and savored the contemporary bohemian lifestyle of his artistic milieu. When not making family portraits for hire, Lange enjoyed composing with the sharp, thin lines of her husband and the round, soft shapes of her young sons.

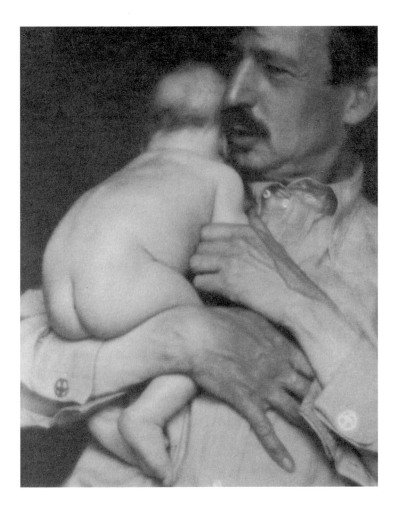

PLATE 2

Hopi Man, Arizona

1926 gelatin silver print
from a 1923 negative
Image: 18.4 × 19.7 cm
(7 ¼ × 7 ¾ in.)
Mount: 19.3 × 20.4 cm
(7 ⁹⁄₁₆ × 8 in.)
84.XP.912.4

The West was Dixon's subject as well as the inspiration for his own personal style.
His second son, John, described his father's usual "costume" as a well-cut black suit, a green silk necktie, and a black narrow-brimmed Stetson. He also wore high-heeled cowboy boots and carried a black walking stick. A stylized thunderbird appeared on his cufflinks (see pl. 1) and watch fob. He was recognized on the streets of San Francisco as an authentic Western character and prided himself on knowing the country that he portrayed in book illustrations, murals, and paintings. According to his son Daniel: "Maynard knew the West like a book—like an encyclopedia. He knew about longhorns and mustangs, and guns and saddles, and eagles and wolves, and wagons and Indian ways—all kinds of Indian customs and arts and ceremonies and beliefs. He knew the myths and legends as well as the facts" (*The Thunderbird Remembered*, 1994). Dixon learned from historians like Lummis and frontiersmen such as John Lorenzo Hubbell, at whose isolated Arizona trading post he

sometimes stayed. He made horseback sketching trips into the Western landscape and was occasionally accompanied by Lange when she could escape the portrait studio.

This tight cropping of an outdoor portrait of a Hopi Indian, although dated 1926 by Lange on the print, is most likely from a negative made on a 1923 trip the couple took with Dixon's patron, Anita Baldwin, who wanted to study the music of Hopi rituals at Walpi Mesa in Arizona. Lange, in a first attempt at recording the faces of strangers in an unfamiliar setting, made sedentary studies of individuals who agreed to pose. At some point after her negatives—full or bust-length portraits taken from a greater distance than this image suggests—were proofed, Lange chose to isolate this face, squinting in the bright sunlight, and print it so that the features were broadly implied by light and dark. A few lines further define the man's eyes, forehead, and mouth, but his particular identity is eliminated. He becomes, instead, a symbol of an endangered race.

14

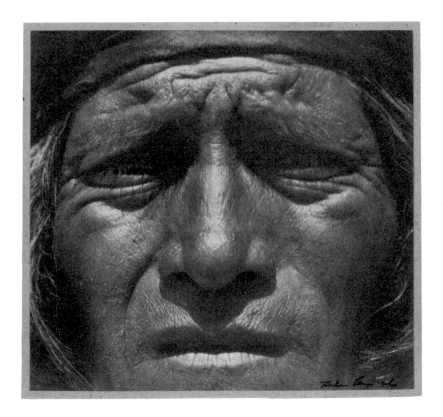

PLATE 3

Juniper Post Fence, New Mexico

1931

Gelatin silver print
Image: 5.7 × 5.6 cm
(2¼ × 2³/₁₆ in.)
Mount: 13 × 10.5 cm
(5⅛ × 4⅛ in.)
2000.50.6

John K. Hillers photographed in New Mexico for the Bureau of American Ethnology in 1879. He was followed by other nineteenth-century photographers who were interested in the history and current practices of Native Americans in the territory (not pro-claimed a state until 1912). Lummis visited in the 1880s, Adam Clark Vroman in 1895, and Edward S. Curtis began his massive survey there in 1903. After the 1916 arrival of the wealthy arts patron Mabel Dodge Luhan, the Taos-Santa Fe region became the des-tination of many American artists, writers, composers, and choreographers. Addition-ally, Taos again became a site of inspiration for talented photographers. Paul Strand worked out of one of Luhan's studios in 1926 and again in the summers of 1930–32; Ansel Adams visited in 1927 and returned in 1929 for a three-month stay.

At Luhan's invitation, the British author D. H. Lawrence and his wife, Frieda, came to stay in the 1920s, bringing their countryman Aldous Huxley along on one visit. Huxley's *Brave New World* (1931) featured a "savage" who must choose between his reservation and an urban utopia engineered by science. Lange and Dixon faced a not-so-different choice and decided to leave San Francisco as the depression worsened. Luhan offered Dixon a studio for painting; he knew and liked the region, having first visited in 1900 at the urging of Lummis. Lange later described their flight from a world "in smithereens": "The world was full of uncertainty, and unrest, and trouble, and we got in [the] car and went" (*The Thunderbird Remembered*, 1994). This seven-month sojourn was a productive time for Dixon. Lange, without a studio and her regular clientele, cared for the house and children. She did, how-ever, make some pictures—of adobe struc-tures, young Taos women, and fence posts —that challenged her previous pictorialist style and restricted bourgeois subject mat-ter. Her camera seemed to capture every-thing but the spectacular landscapes that attracted Strand and Adams.

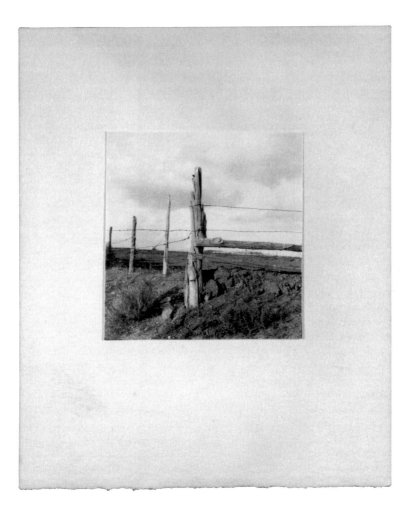

PLATE 4

**White Angel Breadline,
San Francisco**

Circa 1950s gelatin silver print
from a circa 1933 negative
23.5 × 19.3 cm
(9¼ × 7⁹⁄₁₆ in.)
2000.43.1

PLATE 5

**Here Democracy
Survives/
Demonstration,
San Francisco/
"What's Ahead?"**

1934

Gelatin silver print
24.4 × 18.4 cm
(9⅝ × 7¼ in.)
2002.20.1

PLATE 6

**General Strike/
Street Meeting,
San Francisco**

Circa 1965 gelatin silver print
from a 1934 negative
24 × 19.1 cm
(9⁷⁄₁₆ × 7½ in.)
Gift of David and Marcia
Raymond in honor of
their father, Paul Raymond
2001.86

After returning from New Mexico, Lange observed from her studio the increasing number of unemployed workers in the streets of San Francisco. She took her camera outdoors and began to make pictures of groups of men at soup kitchens, May Day demonstrations, and strike rallies. The photographer Willard Van Dyke recognized the quality of this output and arranged a show of the images at his studio gallery. He also wrote a critique of Lange's work for the October 1934 issue of *Camera Craft* that was illustrated with five of her photographs, including a substantially cropped version of *White Angel Breadline* (pl. 4) and *General Strike/Street Meeting, San Francisco* (pl. 6). He explained Lange's motivation for tracking the "drama of human relations": "In an old Ford she drives to a place most likely to yield subjects consistent with her general sympathies. Unlike the newspaper reporter, she has no news or editorial policies to direct her movements; it is only her deeply personal sympathies for the unfortunate,

the downtrodden, the misfits, among her contemporaries that provide the impetus for her expedition."

Although Lange's subject was the masses, she usually picked out one figure or face to delineate clearly, someone who would represent the crowd, a person the viewer could care about. This compositional technique was employed by contemporary muralists, many of them imitating the Mexican model. Lange became skilled at photographing groups so that the scale of background figures appeared uniform and the room between them seemed compressed. Against this flat, shallow space, the individual she chose to distinguish from the multitude was easily detected and his or her magnetic features recognized. In plate 5, Lange's sensitive treatment of the worker and her title *Here Democracy Survives* confirm her liberal view of the volatile situation that existed between labor and capital in San Francisco.

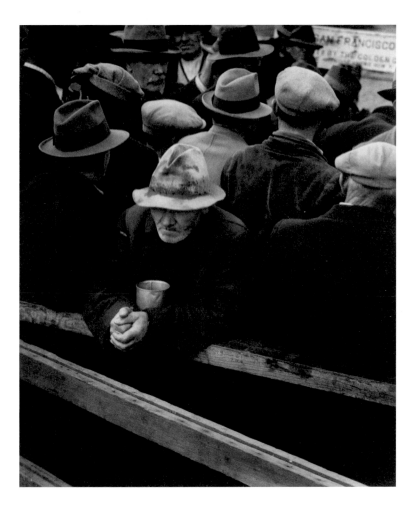

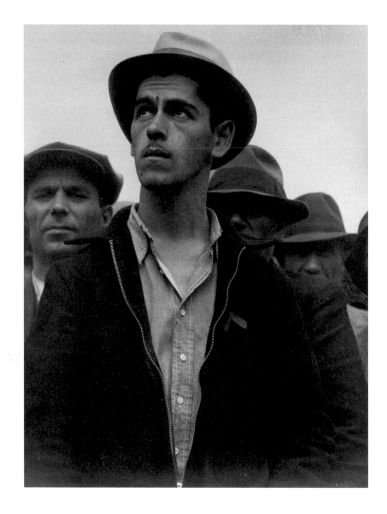

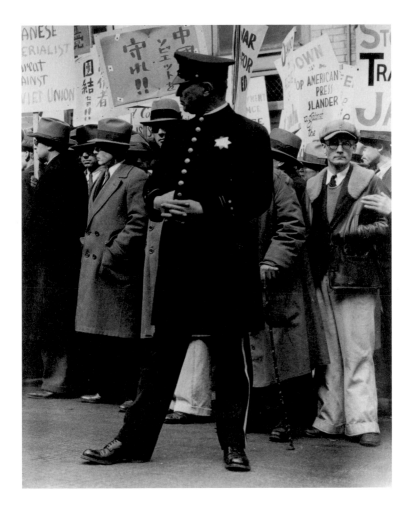

PLATE 7

PLATE 8

PLATE 9

Paul Taylor with Migrant Workers, Imperial Valley, California
1935

Gelatin silver print
17.8 × 24.1 cm
(7 × 9½ in.)
2000.43.2

Gesturing Farm Worker, Probably Imperial Valley, California

Circa 1960s gelatin silver print, from a 1935 negative
26 × 32.4 cm
(10¼ × 12¾ in.)
Purchased with funds donated by Dan Greenberg and Susan Steinhauser
2001.44

Cantaloupe Pickers, Mexicans, at End of Day in California Melon Fields/Mexican Labor Off for the Melon Fields in the Imperial Valley

Circa 1950s gelatin silver print, on Masonite mount, from a July 1935 negative
18.9 × 23.7 cm
(7⁷⁄₁₆ × 9⁵⁄₁₆ in.)
2000.50.7

Paul Schuster Taylor was raised in western Iowa and attended the University of Wisconsin before doing graduate work at the University of California, Berkeley. He received a Ph.D. in labor economics there in 1922 for his study of merchant seamen. For the next forty years he taught in the economics department, becoming a full professor in 1939. His fieldwork on Mexican immigration began in 1927 with research money from the Social Science Research Council and the Guggenheim Foundation. The results of this study were published as the multivolume *Mexican Labor in the United States* (1928–34). In the early 1930s he started contributing articles to a variety of scholarly journals and progressive publications, including *Rural Sociology, Monthly Labor Review, Survey Graphic,* and *American Sociological Review.* In addition, his concern with being in the field, or "on the ground" as he called it, led him to involvement with the Rural Rehabilitation Division of the California Emergency Relief Administration, the Resettlement Administration, and the Social Security Board.

For Taylor, pictures were as important as statistics and analysis; his research methodology included photography from 1927 on. However, before he met Lange in 1934, the pictures that he used were his own. Taylor's young family was his first subject in the 1920s but, apparently inspired by the combination of text and images in the social welfare journal that had published much of Lewis Hine's innovative documentary work — *Survey Graphic* — he chose to take his Kodak with him when he began the study of Mexican migrants. Van Dyke, whose gallery made Lange's pictures available to Taylor in 1934, also exhibited the economist's prints at about the same time. Once a team in the field, Lange made the photographs with her more professional equipment (various Graflex, Rolleiflex, and view cameras) while Taylor continued his interviews with farm workers.

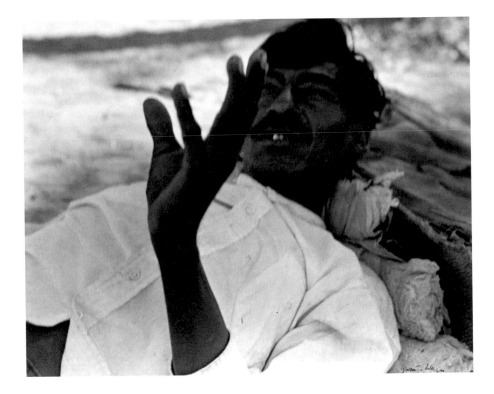

PLATE 10

Pea Pickers,
Nipomo, California
February 1936

Gelatin silver print,
with applied pigment
Image: 19.5 × 24.4 cm
(7 ¹¹/₁₆ × 9 ⅝ in.)
Sheet: 20.3 × 25.4 cm
(8 × 10 in.)
2000.51.3

This print, made in the Washington, D.C., darkroom of the Resettlement Administration and sent to the *New York Times* for publication in August 1936, has pencil inscriptions in several different hands on the verso. Among them are various captions ("Pea pickers in Calif. 'Mam [*sic*], I've picked peas from Calipatria to Ukiah'" and "Members of the roving army of fruit pickers"); date stamps; the RA stamp ("Kindly use the following credit line: RESETTLEMENT ADMINISTRATION PHOTOGRAPH BY Lange"); and the picture editor's directions ("single × 2 col, 4 × 3 ¼, tonight"). The *Times* art department worked on the picture itself, applying white, gray, and black pigment to make the figures appear more three-dimensional and to set them off from their auto/home and the grassy foreground. Crop marks provide further aids to the printers responsible for making zinc printing plates and laying out the feature.

The truck or car modified to act as a home for migrants traveling from job to job was a common sight on California highways and at roadside camps in the 1930s. In this case, a truck has been adapted to provide sleeping quarters—complete with sunroof—and other household requirements. The couple has obviously covered a lot of miles, as the man is quoted as saying, picking peas from the Imperial Valley of Southern California to the northern Ukiah Valley of Mendocino County. Lange found them in Nipomo, midway up the coast and midway through another season that would cause them to traverse the length of the huge state.

John Steinbeck describes the importance of the truck to the Oklahoma farmers of *The Grapes of Wrath* (1939) as they load theirs to begin migrant life: "The house was dead, and the fields were dead; but this truck was the active thing, the living principle. The ancient Hudson, with bent and scarred radiator screen,... this was the new hearth, the living center of the family."

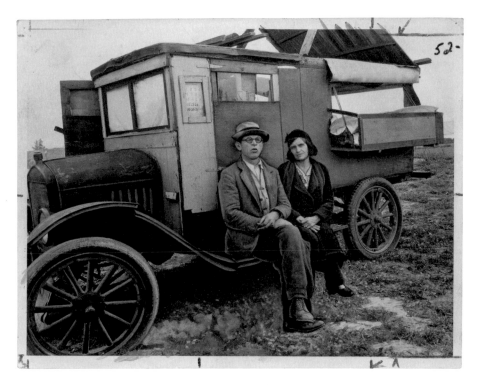
52.

PLATE II

Rainy Day in Camp
of Migrant Pea Pickers,
Nipomo, California

February 1936

Gelatin silver print
19.4 × 24.4 cm
(7⅝ × 9⅝ in.)
2001.4

Nipomo, California, was a town of 750 citizens in the late 1930s. It is located near the Pacific coast, north of Santa Maria, just east of U.S. 101, in San Luis Obispo County. *The WPA Guide to California* reported in 1939 that the Santa Maria Valley raised grain, beans, and seed; in fact, it stated that "for miles the countryside along US 101 is planted with beans." In the winter of 1936, during the pea harvest, Lange worked in the area, documenting conditions at migrant camps for the Resettlement Administration. The captions now attached to her RA pictures from this picking season in California include such comments as "Pea Picker's home. The condition of these people warrants Resettlement camps for migrant agricultural workers." Her intent was always to make a difference, to bring about improvements in the lives of the desperate people she encountered.

Here, Lange makes a broad view to document as much of the environment as possible: the large tents (one incorporating a working stove), the essential automobile (also needed in running order), the roadside row of eucalyptus trees offering some protection from the elements, and the ubiquitous water and mud resulting from days of rain. Included in this cold, wet scene typical of the then-pervasive poverty in California are two very willing group portraits: one in the center of the picture of three boys, probably brothers; the other, perhaps representing members of the same family, of two young women and two children. The photographer directs them from across the huge puddle. The subjects are all smiling as they watch and listen and stand perfectly still, this in spite of conditions that Steinbeck re-creates in his story of the Joads: "And when the puddles formed, the men went out in the rain with shovels and built little dikes around the tents. The beating rain worked at the canvas until it penetrated and sent streams down. And then the little dikes washed out and the water came inside, and the streams wet the beds and the blankets."

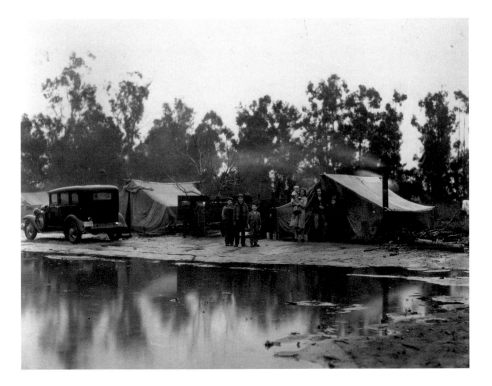

PLATE 12

Destitute Pea Pickers, California

March 1936

Gelatin silver print
19.1 × 24.3 cm
(7 ½ × 9 ⁹⁄₁₆ in.)
2001.51.5

Florence Leona Christie was born in 1903 to Cherokee parents living in Indian Territory (now part of Oklahoma). At seventeen she married Cleo Owens, the son of a farmer from Missouri. In 1926 the couple and members of her husband's family moved west, settling in Oroville, California. By 1931, when Cleo died of tuberculosis, Owens had had five children and was pregnant with a sixth. She worked at farm labor and in restaurants to support her large family. After an unhappy relationship and another pregnancy, she went back to Oklahoma briefly in 1933, returning to Shafter, California, where she met a man from Los Angeles who would be her companion until the 1950s. Owens gave birth to an eighth child in 1935 and continued to be the major breadwinner. The family had been in the Imperial Valley picking beets and were on their way toward Watsonville to work in the lettuce fields when car trouble forced them to stop at the Nipomo pea pickers' camp, where Lange found Owens.

The photographer made six four-by-five-inch negatives of Owens: two with four of her children, one with just the baby, two with the baby and one toddler, and then one with three of the children in the picture that became the best known, *Migrant Mother* (pl. 13). Lange used her Graflex in a horizontal, or "landscape," orientation for four of the images, then rotated the back of the camera and also made two vertical, or "portrait," compositions. This print is from the fourth of her six negatives. It is the photograph the *New York Times* chose to publish in the "Rotogravure Picture Section" on Sunday, July 5, 1936, cropping it substantially on either side. The section was headlined "Dust, Drought and Erosion Sweep Fifty Million Mid-West Acres, While the Government Fights to Lift the Pall of Misery and Desolation," and the caption for this picture reads (erroneously) "Gazing into the Future and Seeing Dust. A refugee family, from the drought area, camped near San José, Calif., for the duration of the pea harvest. Then, with the price of a tankful [*sic*] of gasoline, they will strike their tent and wander on."

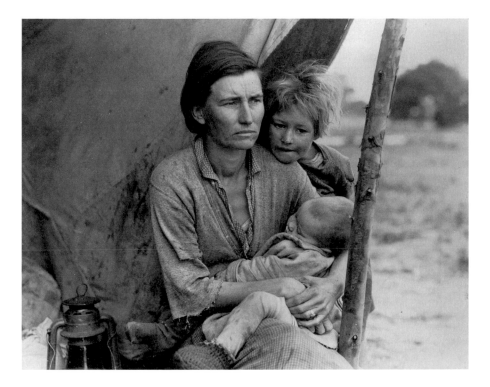

PLATE 13

Human Erosion in California / Facing Starvation / Starvation / Migrant Mother, Nipomo, California

March 1936

Gelatin silver print
34.1 × 26.8 cm
(13 ⁷⁄₁₆ × 10 ⁹⁄₁₆ in.)
98.XM.162

The first publication of this renowned image occurred on March 11, 1936, on the third day that the *San Francisco News* ran a story about the pea pickers' camp at Nipomo. It was also featured as a full-page reproduction in the September 1936 issue of *Survey Graphic*, titled "Draggin'-Around People" and captioned "A blighted pea crop in California in 1935 left the pickers without work. This family sold their tent to get food." Also in this issue was an article by Taylor entitled "From the Ground Up." His report on demonstration projects of the New Deal's Resettlement Administration in Arizona, Utah, New Mexico, and California was illustrated with four more pictures by Lange.

Since it was first published, this composition, best known as *Migrant Mother,* has come to represent not only the pictorial archive created by the RA/FSA during the 1930s but also the Great Depression itself. Posters and other publicity of later activists fighting racial, economic, and political oppression have borrowed from Lange's icon of the time. The handsome, androgynous face, the pose of stoic anxiety, and the encumbrance of three young children proved to be universal attributes. With Lange's artistry, Owens took on the timeless quality of Eugène Delacroix's strong female rebel (*Liberty Leading the People*), Jean-François Millet's peasant woman (the agrarian ideal), Honoré Daumier's laundresses (the working woman), and Käthe Kollwitz's proletarian woman warrior (one of the mothers leading her *Peasants' War*).

Owens, although she became famous, did not enjoy, even momentarily, the life of a celebrity. She had three more children and kept moving with her family, following the California crops. She did become involved in efforts to organize farm labor and would sometimes serve as the straw boss, one who negotiates wages for migrants as the picking season begins. She was still working in the fields at the age of fifty before finally marrying again (to George Thompson) and settling into a stable life in Modesto, California.

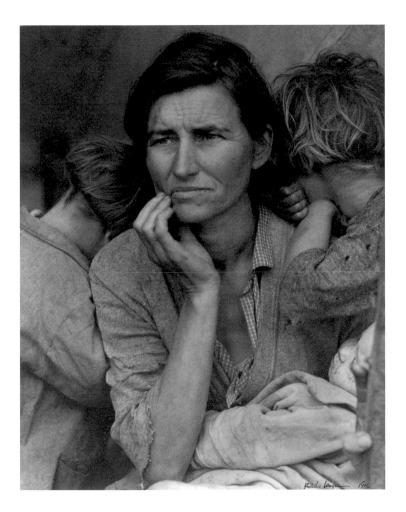

PLATE 14

J. R. Butler, President of the Southern Tenant Farmers Union, Memphis, Tennessee

Circa 1950s gelatin silver print,
on Masonite mount,
from a June 1938 negative
33.7 × 26.4 cm
(13¼ × 10⅜ in.)
2000.50.10

Tenancy was the post-plantation system of cultivation by families who owned their mules and tools but paid their lessor with crop and feed and thus were allowed to stay on the land, although usually without chance of ownership. According to the sociologist Margaret Jarman Hagood, with whom Lange traveled in 1939, it was the biggest economic problem facing the country in the late 1930s. The depression only meant further exploitation for these farmers, who already had a hard time staying out of debt and were sometimes obliged to give the landlord half of their crop in order to retain shelter and a livelihood. Tenant farmers and sharecroppers organized in 1934 in an attempt to pressure both the Roosevelt Administration and the landowners to recognize their dilemma. The latter responded with threats and evictions for the union leadership.

J. R. Butler, who is identified as a country schoolteacher and a sharecropper in the exhibition catalogue to Lange's 1966 retrospective at the Museum of Modern Art, New York, was the president of the Southern Tenant Farmers Union and was probably presiding at a meeting of the group when Lange photographed him in Memphis. The full negative presents a waist-length portrait of Butler, hair recently cut, dressed in a reasonably new shirt and striped tie with a couple of pens clipped to his breast pocket. Positioned against the background of an empty, mottled wall that has a damp, institutional look, he is obviously posing for Lange's camera, but his wide-eyed, questioning expression seems to convey surprise nevertheless. The extreme cropping of the present print may be the result of what John Szarkowski has called Lange's redefinition of pictures through later "reframing." Here she utilizes just the central part of her negative. In stripping almost everything away save the rough, lined surface of Butler's face and the worried depth of his eyes, she creates a confrontation, not simply with a farmer or a struggling union leader, but with the humanity of one individual.

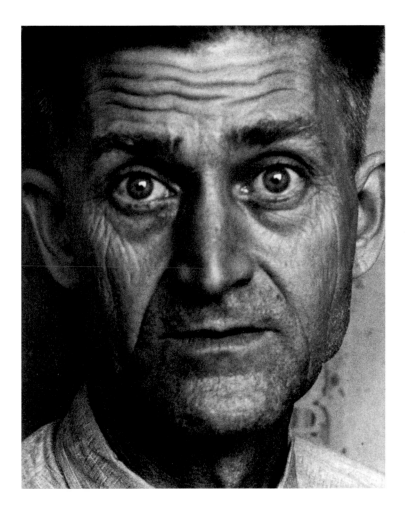

PLATE 15

Stoop Labor in Cotton Field, San Joaquin Valley, California

Circa 1950s gelatin silver print,
on Masonite mount,
from a 1938 negative
23.5 × 30 cm
(9¼ × 11¹³⁄₁₆ in.)
2000.50.11

An American Exodus: A Record of Human Erosion was published by Lange and Taylor in 1939 as a collaborative effort between "a photographer and a social scientist." The book was divided into six sections — Old South, Plantation under the Machine, Midcontinent, Plains, Dust Bowl, and Last West — each containing a portfolio of captioned images by Lange followed by a historical text by Taylor. The pictures in the first section consisted of field laborers and poor homes photographed in Alabama and Georgia. The anonymous cotton picker seen here serves to illustrate Taylor's essay, appearing just above his opening paragraph. Lange's view of the man's form makes this difficult, exhausting work look graceful; the coarse cloth of his overalls and heavy bag crease and hang in beautiful ways.

In the revised and expanded edition of *An American Exodus,* issued by the Oakland Museum in 1969, this picture is accompanied by a caption from Taylor's field notes from the San Joaquin Valley in November 1938: "Migratory cotton picker paid 75 cents per 100 pounds. A good day's pick is 200 pounds. CIO union strikers demand $1 per 100 pounds." According to *The WPA Guide to California,* the state had been producing an important variety of cotton (Alcala) since it was introduced in 1917; in 1937 the average yield per acre was nearly twice that of the rest of the country. Although Lange did photograph workers planting and harvesting cotton in Southern states, this image was actually made of a migrant laborer in California.

The work of picking cotton occupies a chapter of *The Grapes of Wrath.* Like other seasonal labor, it was a possibility for the Joad family, who had fled the dust bowl conditions of Oklahoma. In a conversational style, seemingly from the migrant picker's viewpoint, Steinbeck describes the process: "Now the bag is heavy, boost it along. Set your hips and tow it along, like a work horse.... Good crop here. Gets thin in the low places, thin and stringy. Never seen no cotton like this here California cotton."

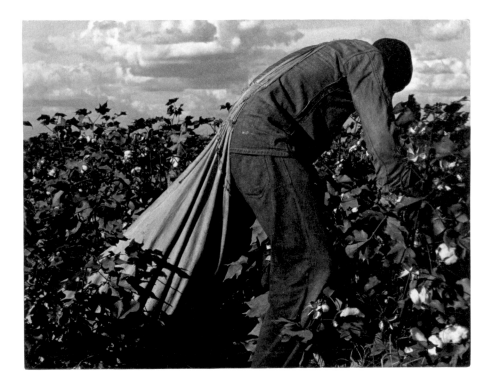

PLATE 16

**First Days of
Unemployment
Compensation
in California:
Waiting to File Claims**
January 1938

Gelatin silver print
19.8 × 18.4 cm
(7 13/16 × 7 1/4 in.)
2000.50.9

In the Farm Security Administration file
(now in the Prints and Photographs Division,
Library of Congress), the series of pictures
from which this image comes is captioned
"Unemployment benefits aid begins. Line
of men inside a division office of the State
Employment Service office at San Francisco,
California, waiting to register for benefits
on one of the first days the office was open.
They will receive from six to fifteen dollars
per week for up to sixteen weeks. Coinci-
dental with the announcement that the fed-
eral unemployment census showed close
to ten million persons out of work, twenty-
two states begin paying unemployment
compensation."

Lange's documentation of the beginnings
of New Deal unemployment insurance in
California was available through the FSA for
use in picture magazines, newspaper articles,
and government reports. *Survey Graphic,*
the progressive journal to which she and

Taylor contributed, reproduced a similar
image from this session to introduce an
article on the status of the new system about
a year later. Explaining why some states
had trouble keeping up with claims from the
millions of unemployed, the March 1939
piece reminded readers: "As was to be
expected, the machinery creaks. To start a
load moving is harder than to keep it going
once the wheels turn, but this was only part
of the difficulty. Another was that the load
itself was heavier at the start than the normal
weight the machinery will have to carry."

Between 1935 and 1939 Lange's beat
for the RA/FSA was often San Francisco.
When not traveling to cover dust bowl
farmers or Southern sharecroppers, being
"in the field" meant photographing the
unemployed in flophouses in the Mission
District, in hockshops on skid row, or
at Salvation Army meetings, listening to the
band and the preacher.

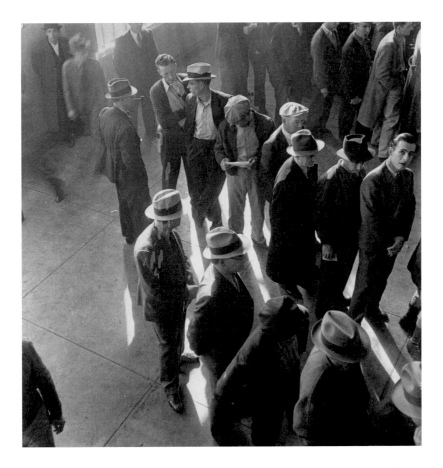

PLATE 17

Doorstep Document/
Grayson, San Joaquin
Valley, California/
Death in the Doorway

Circa 1960s gelatin silver print
from a 1938 negative
19.2 × 23.8 cm
(7 9/16 × 9 3/8 in.)
2000.43.3

Regarding this picture, Lange's field notes report: "Grayson was a migratory agricultural laborers' shack-town. It was during the season of the pea harvest. Late afternoon about 6 o'clock. Boys were playing baseball in the road that passes this building, which was used as a church. Otherwise, this corpse, lying at the church door, was alone, unattended, and unexplained." The full negative she made there represents not just this doorway but the entire whitewashed gabled facade. The concrete steps in front of the entrance and foundation blocks at either side are visible. Apparently the form in the doorway was what drew Lange to the scene, however; it has been suggested that she later realized this central feature was important enough to carry the composition and proceeded to concentrate on the portion of the negative with the shallow portal holding the body. She published an even more severely cut-down version in the 1940 *US Camera Annual*. Bearing the title *Doorstep Document*, it eliminates the three plain boards that frame the doorway, making the depth of the threshold less evident and the wrapped figure and worn double doors more prominent and funereal.

It is not known why Lange identified the form as a corpse rather than a homeless person. Today we are more inclined to think it is the latter, since such scenes are common. The relaxed, uncovered pose of the feet indicates a voluntary reclining position. Lange was also some distance away when she made the exposure. One of the playing children may have suggested the corpse idea to test its shock value, and perhaps Lange adopted it for future propaganda purposes. Grayson was just a small town southwest of Modesto, and this church was probably one of the few places of refuge it offered.

It would seem peculiar for the feet of a dead person to be exposed. Here they represent the life, the personality, of this anonymous citizen. Always sensitive to the appearance and performance of others' feet, due to her own deformity, Lange made hundreds of photographs on the theme. This one is among the most melancholy.

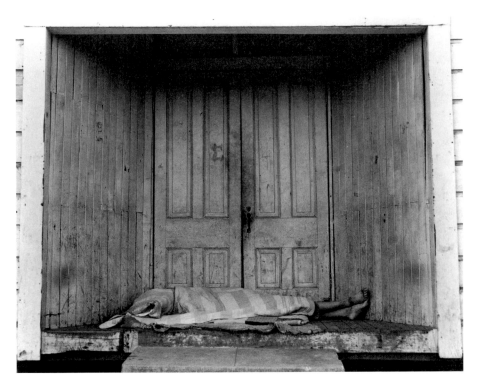

PLATE 18

The Road West, New Mexico / Highway to the West / U.S. 54 in Southern New Mexico

Circa 1965 gelatin silver print
from a 1938 negative
18.7 × 23.8 cm
(7⅜ × 9⅜ in.)
2001.36.1

The real migrants pictured in *An American Exodus* and the fictional ones portrayed in *The Grapes of Wrath* were all part of the road culture that developed in 1930s America. The era's most talented balladeer, the Oklahoman Woody Guthrie, wrote song after song about this "hard traveling," including "Going Down the Road," "I Ain't Got No Home," "Lonesome Soul Blues," and his ode to Route 66, "Will Rogers Highway." John Ford's 1940 film version of *The Grapes of Wrath* opened with a view of an empty highway, setting the scene for an epic story that takes place almost entirely on the road or just off of it in a temporary migrant camp. Steinbeck devotes chapter 12 of his novel to what he called "the main migrant road" and manages to contain its immense significance in one sentence: "66 is the path of a people in flight, refugees from dust and shrinking land, from the thunder of tractors and shrinking ownership, from the desert's slow northward invasion, from the twisting winds that howl up out of Texas, from the floods that bring no richness to the land and steal what little richness is there."

Lange's *Highway to the West* was the closing image for the third section in *An American Exodus*—Midcontinent—which is specifically about rural conditions in Oklahoma and includes six pictures of families on the road. When the book was revised in 1969 under Taylor's direction, this simple composition of lines indicating pavement, prairie, and sky served as the signature image, appearing at the beginning and end of the volume. Lange's skill in treating the subject of a vast Western landscape may have come in part from exposure to Dixon's canvases of the early 1930s. Such paintings as *The Plains* (1931) and *Approach to Zion* (1933) show his ability to express an enormous horizontal expanse of land and sky while subtly connecting foreground and background with the lines of a road. However, Lange's subject in 1938 was the road itself, and it, appropriately, dominates her vision of the landscape.

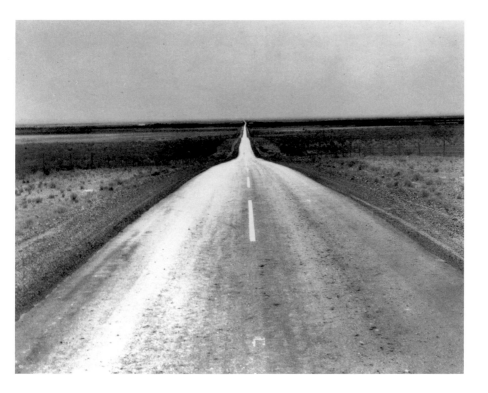

PLATE 19

Farm Workers, South
of Tracy, California
1938

Gelatin silver print
15.1 × 15.1 cm
(5¹⁵⁄₁₆ × 5¹⁵⁄₁₆ in.)
2000.43.4

In 1938 Lange traveled by car to Arizona, New Mexico, Texas, Oklahoma, Arkansas, Tennessee, Mississippi, Georgia, and Missouri on assignment for the Farm Security Administration. She also put hundreds of miles on her car in California, photographing the displaced farmers who continued to arrive from the Plains states and the Deep South. Due east of San Francisco near the railroad town of Tracy, a stopping place for truckers driving loads through the Altamont Pass as well as for migrant laborers looking for work, she found the makings of a picture that might encompass the nostalgia of regionalist painting, the proletarian agenda of social realism, and the authenticity of FSA documentation.

The image contains a farm couple, representatives of the agrarian ideal, but clearly landless, working in the vast fields of an absent landlord. Laboring in the hot sun, both carry a load of recently picked produce to be weighed for payment in miserable wages. The rural landscape is planted as far as the eye can see; however, it is farmed with machinery and dozens of seasonal workers, like these, who are just passing through. The road next to the fields is a prominent foreground element, as it is in many of Lange's compositions. Here it is dirt instead of a paved highway, giving the scene a more rural atmosphere, but, nevertheless, referring to the constant movement of these new homeless farmers, just as do the cars parked behind them.

Lange's anonymous subjects are shown shouldering the burden of their field work and are rendered, as always, in sharp focus for a detailed representation of both figures and context. In these respects her creations are similar to those of the Iowa regionalist Grant Wood, whose meticulous paintings celebrated the everyday rituals of Midwestern people. His theme, and that of such contemporaries as Thomas Hart Benton and John Steuart Curry, was the life of this nation. Lange and her FSA supervisor, Roy Stryker, were dedicated to the same idea, for purposes of the record as well as the needs of reform.

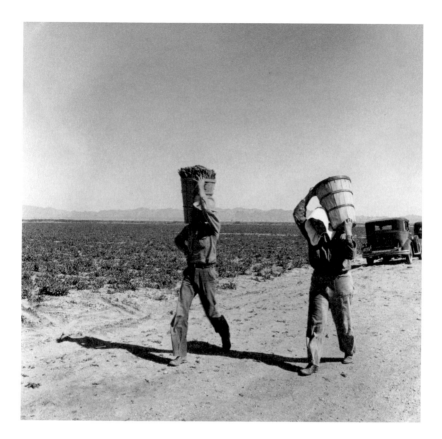

PLATE 20

Abandoned Farm
in Mechanized Wheat
Fields, Oklahoma

Circa 1938

Gelatin silver print
13 × 24.4 cm
(5⅛ × 9⅝ in.)
2002.5

"The houses were left vacant on the land, and the land was vacant because of this." Thus Steinbeck begins to describe the scene left by the Joads and other Oklahoma families as they departed for California. He goes on to detail the damage that will be done to the empty houses by the sun, the wind, the animals, the boys from town, and even the weeds, now that the residents are gone: "The weeds sprang up in front of the door-step, where they had not been allowed, and grass grew up through the porch boards. The houses were vacant and a vacant house falls quickly apart. Splits started up the sheathing from the rusted nails. A dust settled on the floors, and only mouse and weasel and cat tracks disturbed it." The novelist also addressed the impact and attributes of the tractor, now the sole inhabitant of many farms: "When a horse stops work and goes into the barn there is a life and a vitality left.... There is a warmth of life in the barn, and the heat and smell of life. But when the motor of a tractor stops, it is as dead as the ore it came from."

Taylor, writing the same year in *An American Exodus,* employed a more matter-of-fact voice in outlining the reasons for the Oklahoma crisis: "For a generation the labor agents for the cotton growers of Arizona and California have known that Oklahoma farm folk are among the most footloose in the country.... By a curiously symbolic coincidence Oklahoma is the most wind-blown state in the country, its newly-broken red plains are among the worst eroded, and its farm people are among the least rooted to the soil. Adding to its traditional unsettlement, Oklahoma shares with neighboring states the effects of protracted agricultural depression, drought, depletion of mineral resources, destruction of soils, displacement of farm workers by mechanization, and accumulation in its poorest rural sections of population rebuffed by industrial centers of the North." Lange expressed the words of both novelist and economist in this wide view of a wheat field, empty house, and quiet windmill.

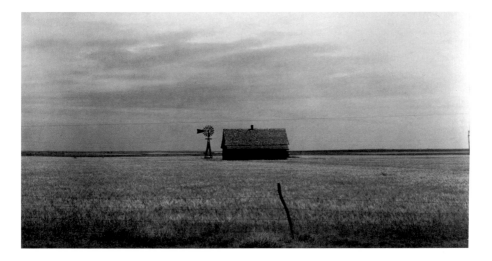

PLATE 21

Amana Society Village, Iowa

Circa 1960s gelatin silver print
from a 1941 negative
27 × 34.3 cm
(10⅝ × 13½ in.)
2000.50.13

After years of completing assignments issued from Washington, D.C., Lange was anxious to have time to herself, working in the field and in the darkroom at her own pace. To this end she applied for a yearlong Guggenheim Fellowship in 1940 with this simple statement of purpose: "To photograph people in selected rural American communities. The theme of the project is the relation of man to the earth and man to man, and the forces of stability and change in communities of contrasting types." She and Taylor, whose academic pursuit continued to be the study of agricultural labor, planned a trip to Iowa, South Dakota, and Nebraska. They hoped to visit various cooperative communities settled by nineteenth-century immigrants, such as the Amana Society villages in eastern Iowa.

Taylor, who grew up on the other side of the state, in Sioux City, may have suggested Iowa as a destination. He described the history of this group in a 1942 article for the Department of Agriculture: "About 1855, a German Protestant sect, the Community of True Inspiration, bought 26,000 acres of good land in eastern Iowa. The grandchildren, great-grandchildren and even a few of the children are there today. Their forefathers pooled their goods when they went to the frontier before the Civil War and founded the seven villages of Amana. Their religion didn't command that, like early Christians, they should have all things in common, but it permitted it." Taylor goes on to say that in 1932 the community "voted out communism in the form they had known it." The enormous farm was, however, still run as one unit by society members, such as this couple, who are shelling peas together in what appears to be a photographic variation on Wood's signature painting, *American Gothic* (1930).

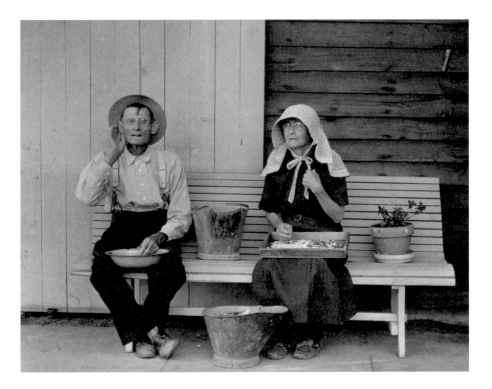

PLATE 22

**Hutterite Sampler,
South Dakota**

1941

Gelatin silver print
19.2 × 24.3 cm
(7 %₁₆ × 9 %₁₆ in.)
2000.50.14

The arrest of Lange's brother, Martin, for, ironically, swindling unemployment benefits, caused her to have to discontinue her precious sabbatical and ultimately postpone it until the late 1950s. It was also her family, however, who instilled in her an early appreciation of handicrafts and influenced her choice of subjects, such as this elaborate and skillfully executed embroidery sampler. Grandmother Sophie Lange, with whom Dorothea lived during her teenage years, was an expert seamstress. Three great-uncles were lithographic printers who practiced their craft in America after training in Germany. Dixon was an early collector of Southwestern Indian blankets, baskets, and pots. His studio and, no doubt, home were filled with these traditional objects. Later, when Lange was housebound due to illness, she liked to decorate her muslin blouses and skirts with embroidered patterning done on a sewing machine.

Lange's understanding of the handwork involved in mastering the varieties of design illustrated here, as well as her highly developed sense of the graphic line, probably contributed to her recognition of this feminine achievement. The making of a sampler, an exercise in ornamental embroidery that was originally a test of a girl's household skills, had been practiced in Germany for centuries and was brought to the United States by rural German immigrants, like those of the South Dakota Hutterites or the Amana Society. Lange's own heritage was German, which may have increased her admiration for this piece. She might have related the accumulation of so many types of characters and decorative motifs, tightly organized and carefully rendered, to her own recent efforts to document the many faces of the Great Depression.

PLATE 23

Interior View of Japanese American Citizens League Headquarters, Centerville, California

Circa 1960s gelatin silver print
from an April 7, 1942, negative
20.2 × 30.5 cm
(7 ¹⁵/₁₆ × 12 in.)
Gift of the John Dixon
Collection
2000.52.1

The assembly and internment of 110,000 people of Japanese descent, two-thirds of them born in the United States, began in the spring of 1942 after President Roosevelt issued Executive Order 9066 "to prescribe military areas in such places and of such extent as he [the Secretary of War] or the appropriate Military Commanders may determine, from which any or all persons may be excluded, and with such respect to which, the right of any person to enter, remain in, or leave shall be subject to whatever restrictions the Secretary of War or the appropriate Military Commander may impose in his discretion." The West Coast — California, Oregon, and Washington — was designated Military Area No. 1, a place from which Japanese Americans (resident aliens and native born, families and orphans) were to be excluded. This area was also, of course, where the majority of them lived. Voluntary relocation was briefly attempted, then assembly centers and internment camps were quickly established to move

people out of state or confine them to concentration camps within state lines.

Lange was hired by the War Relocation Authority to photograph this process, a new migration that Taylor described in a 1942 *Survey Graphic* article as "the largest, single, forced migration in American history." She took her job very seriously and made pictures such as this one before the packing, tagging, and transporting of people actually began. Her still life concisely illustrates a part of the creed of the Japanese American Citizens League as stated in 1940: "Although some individuals may discriminate against me, I shall never become bitter.... I am firm in my belief that American sportsmanship and attitude of fair play will judge citizenship and patriotism on the basis of action and achievement, and not on the basis of physical characteristics." Ironically, the organization initially backed the evacuation order and encouraged its members to cooperate—to give up property and livelihood — so that the nation could be secured.

PLATE 24

Pledge of Allegiance, Rafael Weill Elementary School, San Francisco

Circa 1960s gelatin silver print
from an April 20, 1942, negative
34 × 25.6 cm
(13⅜ × 10⅛ in.)
2000.50.16

As far as Lange was concerned, her assignment from the government to document the evacuation of Japanese Americans included picturing their lives in the San Francisco area before and after being interned. She made this image at a public school in April, days before citizens like the girl in the center and her family were given numbers and transported to concentration camps for the remainder of World War II. Three of the ten locations established were in California. One of these, called Manzanar, was built in the Owens Valley on land leased to the federal government by the city of Los Angeles. Formerly fertile orchard country, the area had become a desert region since its water had been diverted to L.A. A sociological study published by the University of California in 1946, *The Spoilage (Japanese American Evacuation and Resettlement,* vol. 1), quoted one internee's description of his new environment: "The desert was bad enough. The mushroom barracks made it

worse. The constant cyclonic storms loaded with sand and dust made it worst. After living in well furnished homes with every modern convenience and suddenly forced to live the life of a dog is something which one can not so readily forget."

The purpose of Lange's WRA assignment was the complete antithesis of her earlier FSA work; rather than using these photographs for propaganda, the government intended them to be locked away as documentary evidence. Perhaps this kept the subject from becoming part of the leftist agenda that was so concerned about fascism in Europe. Somehow the imprisonment in this country of more than a hundred thousand people because of their ancestry was overlooked. The photographs eventually came to reside in the National Archives in Washington, D.C., and are now also available at the Bancroft Library at the University of California, Berkeley.

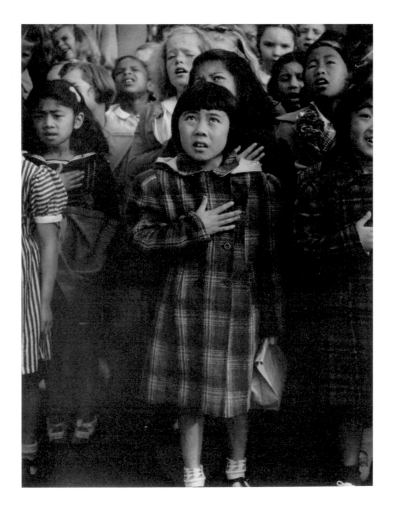

PLATE 25

Lovers, Richmond, California

Circa 1950s gelatin silver print,
on Masonite mount,
from a 1942 negative
25.1 × 25.6 cm
(9⅞ × 10¹⁄₁₆ in.)
2000.50.19

Charles Wollenberg's 1995 book *Photographing the Second Gold Rush: Dorothea Lange and the East Bay at War, 1941–1945* captions a wider view of this scene, which includes a Coca-Cola billboard and a car at left, as follows: "New economic opportunities and wartime cultural changes transformed this young couple's world. MacDonald Avenue, Richmond." This was no doubt true, but probably much more so for the young woman than for her boyfriend, whose face is barely seen but whose arm encircles her neck. It is likely that both were newly employed at the Kaiser Shipyards but unlikely that they held the same jobs or belonged to the same union.

Heavy industry was one of the last modern arenas of male exclusivity, and the shipyard men wanted to keep it that way. To this end, women were kept in the lowest-paying jobs, excluded from most of the unions, and made to adhere to "rules of rude and graceless dress," as Katherine Archibald (*Wartime Shipyard: A Study in Social Disunity,* 1947) called the camouflaging requirements that included covering one's hair, wearing overalls or pants, and doing without makeup or nail polish. Although "Rosie the Riveter," the superwoman of the assembly line, was partly myth, she was a pioneer, especially in the wartime shipyard. Rather than recognizing this as progress, her male colleagues reacted with resentment and calls for women to return to the home. But these new welders, pipe fitters, and, occasionally, electricians wanted to learn a trade and, at the same time, maintain evidence of their femininity. This they attempted to do after their shift, and in spite of the workplace tension between the sexes. The prominent parking meter on the right in this image may refer to the round-the-clock shifts that now governed the workers' lives.

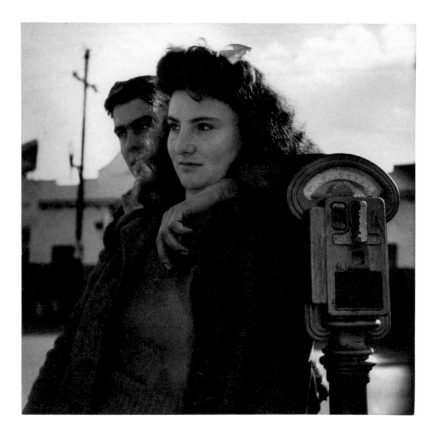

PLATE 26

Richmond, California/
It Was Never Like
This Back Home
Circa 1943

Gelatin silver print
24.8 × 19.7 cm
(9¾ × 7¾ in.)
2000.50.17

Archibald based her *Wartime Shipyard* on interviews and observations she made during two years of employment with the Moore Dry Dock Company in Oakland. Illustrated with four photographs by Lange, this sociological study begins with a description of the factory as a city unto itself: "The shipyard of the war years was a boom town of huddled buildings and long-necked cranes that rose overnight from the mud flats of a bay or river frontage. Through its gates passed twenty or thirty or forty thousand men and women every twenty-four hours."

Lange and her friend of many years, Ansel Adams, were hired by *Fortune* magazine to document this twenty-four-hour cycle in the life of a shipyard (in this case, one of four operated by Henry J. Kaiser) in the quintessential boomtown of nearby Richmond. The resulting article, "Richmond Took a Beating: From Civic Chaos Came Ships for War and Some Hope for the Future," pictured the community's crowded streets, inadequate housing, school annexes, and popular bars. However, the "disunity" Archibald referred to was not the squabbling of the local chamber of commerce over how many temporary quarters to build or whether a new jail was needed for the increase in those arrested for drunken and disorderly conduct, but rather the intensified problems of racial and sexual prejudice, union membership, workplace strata, and class consciousness. For instance, Richmond suddenly had thirty-five times as many African American residents as before the war. They received equal pay, but the unions blocked them, the supervisors resisted promoting them, and the Okies had no understanding of them. This discrimination enhanced existing insecurities, but Lange managed to obtain a casual, between-shifts portrait of this recent arrival in a variant of the image that ran in the February 1945 *Fortune* article.

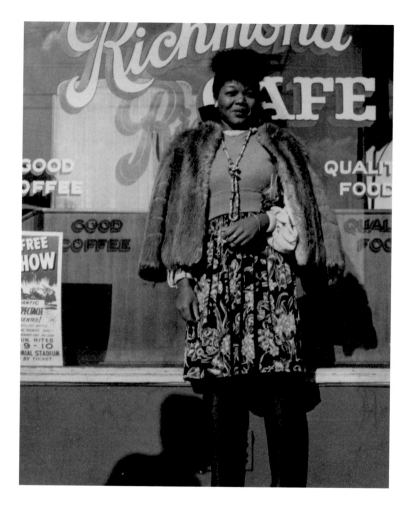

PLATE 27

**Market Street,
San Francisco**

1945

Gelatin silver print
21.1 × 15.4 cm
(8⁵⁄₁₆ × 6¹⁄₁₆ in.)
2000.50.20

PLATE 28

Woman with Pincurls

Circa 1951

Gelatin silver print
18.4 × 20.6 cm
(7¼ × 8⅛ in.)
2001.34.2

PLATE 29

**Three Women
Walking / Market
Street, San Francisco**

1945

Gelatin silver print
19.4 × 22.4 cm
(7⅝ × 8¹³⁄₁₆ in.)
2000.50.21

Lange's interest in the people who compose the American scene shifted from the country's rural inhabitants to those of the city in the 1940s. Working for the Office of War Information, she made pictures of prosperous Americans, some newly arrived in California to assist in the manufacture of ships and arms in the boomtowns of Oakland and Richmond, others longtime residents of Irish, Italian, or French enclaves established by earlier waves of immigrants to San Francisco.

When a colleague, Henry Holmes Smith, solicited an image to use in teaching a 1956 summer workshop on photographic criticism, Lange submitted *Three Women Walking* (pl. 29). Her "photographer's statement" was published with the picture in *Aperture* the following year: "An illustration of the rise in stature traditionally possible in this country. Here we see a grandmother, of obvious peasant stock, and her daughter and her granddaughter on an American street, having been shopping together. We see not only the strong family resemblance and bodily resemblance persistent through three generations,

but the marked record of bodily changes that the years bring. We see also, as a reflection of the time-span between these women, the difference in their clothing (the head-cloth on the grandmother, the high heels and pearls on the granddaughter)."

Plate 27, made in the same place and probably on the same day as plate 29, is, like the latter, as much about human relationships as it is about the world of retail. Here the viewer is asked to consider the complexities of the connection between the woman and child. Additionally, the young woman's sidelong glance at Lange, the middle-aged female observer, makes the moment a personal exchange between artist and model.

The photographer used a more covert approach in a later street portrait (pl. 28). Her elderly subject is carefully dressed—a clean silk scarf tucked into a pressed collar—and fastidiously coiffed. The energy of her tightly wound curls makes a remarkable contrast to the long straight lines of her right ear and wrinkled jaw.

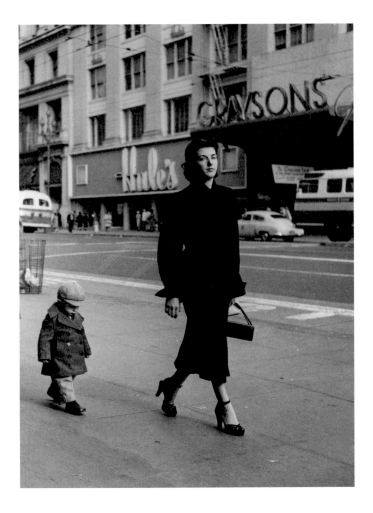

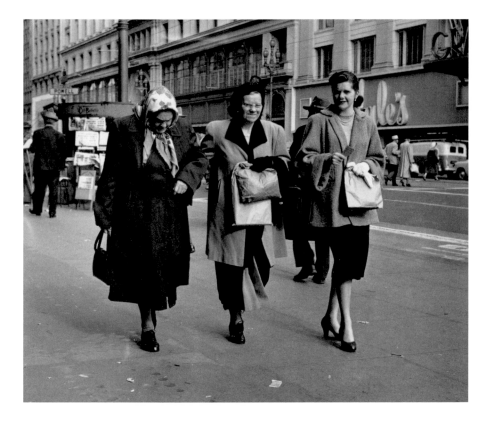

Lange suffered health problems in the late 1940s, but by the early 1950s she wanted to travel again and be part of the current documentary effort. Since the federal government was no longer funding such projects, this meant working for the thriving picture magazines. Lange proposed to *Life* that she and Adams do a project in Utah. They would travel with her son Daniel, who would write text for the article, and her husband, who had a continuing interest in the survival of utopian communities. Their purpose was to record the landscape (see p. 144), built environment, and inhabitants of three towns in southwestern Utah settled in the mid-nineteenth century by Mormons. The grandchildren of some of these pioneers were Lange's subjects during her visit to Gunlock, Toquerville, and St. George in 1953.

In Gunlock, an isolated town of twenty-two families, Lange photographed the mother and child seen in plate 31. She posed the young woman, who appears to be pregnant, with and without her son and at work in her kitchen bottling fruit. Although none of the images of this Utah mother appeared in *Life,* Lange did include her in *The American Country Woman,* a portfolio she prepared in the 1960s, and in a book on the theme, published posthumously. As Lange intended, quotes from some of the subjects accompanied their pictures. The security of this woman's environment is reflected in her statement: "If you run out of money here in Gunlock, you can go and pick yourself something out of the garden."

A sense of stability is also communicated by Lange's compositions from the neighboring village of Toquerville (pls. 30, 32). In his text for *Life* Daniel portrayed this town as a well-preserved part of the past, noting that it did not have "a bank or a movie house, a motel or a café." Old poplar trees lined the broad streets; the well-crafted stone and adobe houses were still livable. It appeared to be a place that held little attraction for the young but one in which the older inhabitants put their trust in what he called their "lofty, lonely faith."

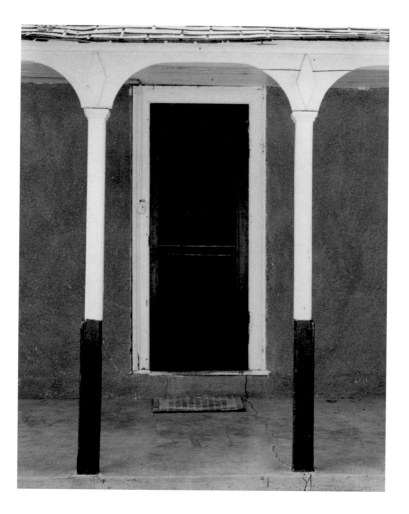

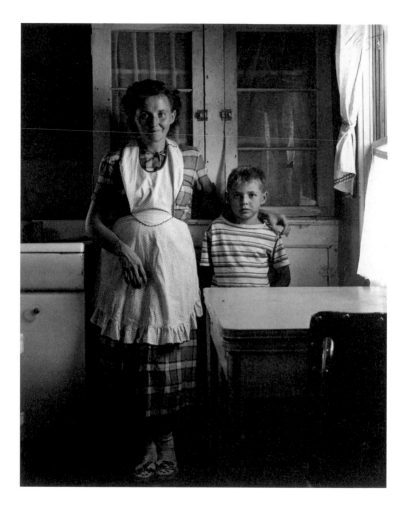

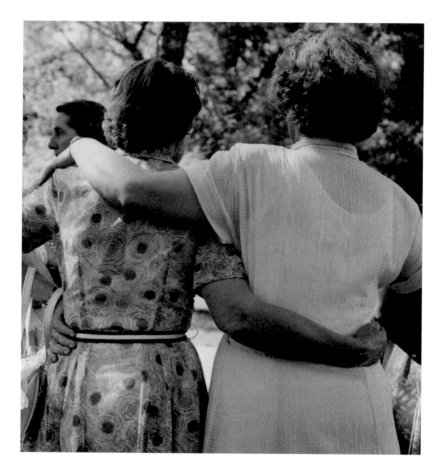

PLATE 33

Utah
1953

Gelatin silver print
17.6 × 17.6 cm
(6$^{15}/_{16}$ × 6$^{15}/_{16}$ in.)
Gift of the John Dixon
Collection
2000.52.4

Lange was first introduced to the people and landscape of Utah in 1933 by Dixon. He took her and their two young sons there to visit Zion National Park in the southwestern corner of the state near the Arizona border. In 1937, two years after the couple divorced, Brigham Young University in Provo acquired eighty-five works by Dixon due to an administrator's enthusiasm for the artist's figurative treatment of victims of the Great Depression. Dixon's ties to the state were further strengthened when he established a summer home and studio there for himself and his third wife, Edith Hamlin, also a painter.

What she had experienced in Utah evidently had a strong effect on Lange as well. On the 1933 trip with Dixon she had photographed an elderly woman named Mary Ann Savage, one of the original Mormon settlers who arrived in 1856. Savage's story of crossing the country as a six-year-old child, of being a plural wife, and of helping to build a nineteenth-century village was no doubt intriguing enough to draw Lange back to the area. When she returned in 1953, she found and photographed Savage's 1936 gravestone as well as her son Riley, then eighty-five years old. Lange also found evidence of the inhabitants who had preceded the Mormons. This was the home of the Paiute Indians, who were ultimately restricted to a reservation northwest of Zion National Park. Lange's composition, at once both landscape and still life, presents a small patch of grass, a man's hand, and the forms of the Indians' carved stone tools. It might be read as an homage to Dixon, who had died in 1946, or as a quiet statement on the destruction of Native American culture.

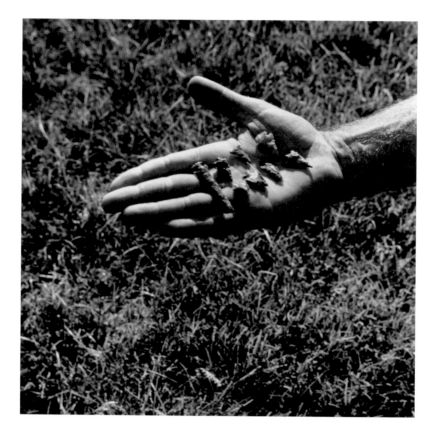

PLATE 34

Father and Child at a Hurling Match, Father Murphy Memorial Park, Newmarket-on-Fergus, Ireland
1954

Gelatin silver print
27.3 × 26.7 cm
(10¾ × 10½ in.)
84.XP.457.13

In 1954 Lange traveled to Ireland with Daniel to make photographs for an article that was published the following year in *Life* as "Irish Country People." The trip and article were prompted by her close reading of a 1937 book by the Harvard anthropologist Conrad M. Arensberg, who collected six lectures under the title *The Irish Countryman.* Arensberg, who based his findings on time spent in the village of Luogh in County Clare, introduces the volume with the chapter "The Interpretation of Custom," which discusses the recent shift in anthropological research from the "history of forms and institutions to a study of behavior." His first pages contain a defense of social anthropology and its practice in the field, specifically in Ireland, which was then attracting archaeologists, ethnographers, and folklorists from the United States.

The *Life* article, which featured twenty of Lange's images, included another view of this man's back and large, rough hands.

Instead of just a single small hand clasping the bigger one on the right, however, the published picture shows two hands clasping the man's. The caption suggests that these hands, "linked almost in symbol of the close family relationship of the country Irish," are those of two boys in the company of their grandfather as they observe a horse show. *Dorothea Lange's Ireland,* published in 1996, presents a photograph of the same back and the face of the child on the right (in fact, a girl) with a caption identifying the two figures as a father and child at a hurling game. Although confusion about the precise familial relationship exists, the present plate does not lose its significance as a reflection of the human bonds, as well as the aesthetic qualities, that Lange found while in the northwest farm country of County Clare. Her *After Church, Toquerville, Utah* (pl. 32), from the year before, is another example of her urge to capture the universal forms of human affection.

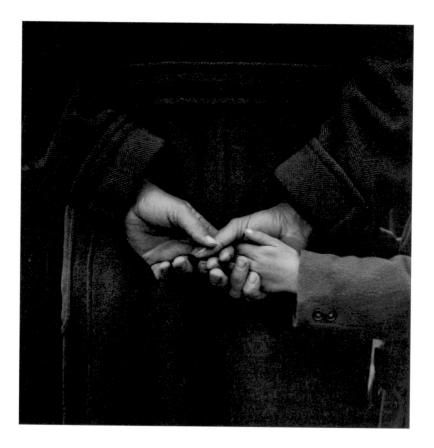

PLATE 35

**A Young Girl
in Ennis, Ireland**
1954

Gelatin silver print
24.1 × 22.9 cm
(9½ × 9 in.)
2000.43.11

Arensberg's book is devoted primarily to the
observation of the traditional upbringing
and adult roles of the Irish male. According
to old customs, Arensberg explains, the Irish
boy is not accepted as an adult until he mar-
ries and inherits the family farm. He is an
apprentice to his stern father up to the point
that he becomes a husband, farmer, and
father himself. The girls in the farm families
of the west-country village he studied were
taught to be silent children, competent house-
keepers, and good mothers.

The four aspects of Ireland that inter-
ested Arensberg, the anthropologist, probably
motivated Lange, the longtime observer of
human behavior, to propose the photographic
project to *Life* as something the public would
enjoy. It was first of all an ancient land that
possessed the remains of the Celtic world
and continued to practice old ways. It was

known as the "land of the devout," with reli-
gious belief an important part of daily exis-
tence. It was also a place where life was hard,
arduous work was necessary, and bleak
realities had to be faced. This aspect, in com-
bination with the wit and good nature that
existed in spite of it, may have been what
inspired Lange's best pictures and made her
time there satisfying.

During her two months in Ireland, Lange
photographed in Ennis, the seat of County
Clare, as well as in the countryside. This local
schoolchild, an intense young woman, seems
to be looking into her own future while
the artist makes her portrait. It's hard to
know whether the girl sees something more
than making a good marital match. A 2001
documentary titled *Photos to Send* retraced
Lange's travels through Ireland and updated
the stories of many of her subjects.

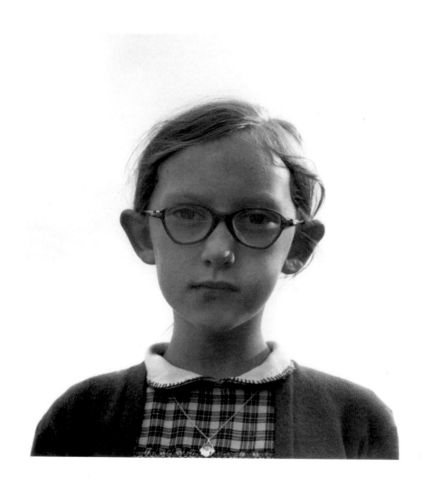

PLATE 36

PLATE 37

PLATE 38

**John Dixon and Son
Andrew, Berkeley,
California/Second Born**
1955

Gelatin silver print
24.8 × 19.5 cm
(9¾ × 7¹¹/₁₆ in.)
2001.34.3

**Helen Pregnant/
Winters, California**
1955

Gelatin silver print
26.7 × 34.3 cm
(10½ × 13½ in.)
2000.43.12

**John Dixon, Daughter
Lisa, Sons Gregor
and Andrew, Berkeley,
California/Third Born**
1958

Gelatin silver print
23.7 × 16.8 cm
(9⁵/₁₆ × 6⅝ in.)
2000.50.41

When her sons were very young, Lange photographed them often, sometimes in the company of their father, listening to him read or watching him paint. During the depression, however, the boys were boarded outside San Francisco, the marriage dissolved, and Lange remarried and began a new career that kept her on the road much of the time. Few family pictures were made, the boys grew up, and in 1945 Lange's ill health confined her to bed.

After Lange recovered, the family became an important subject again. Her sons had married, and during the 1950s they would give her four grandchildren. Daniel, in a contribution to the catalogue for an exhibition at the Oakland Museum in 1978, offers that his mother was recording "the family" as she photographed her sons and grandchildren: "I believe that my mother had given herself an assignment. Between bouts of illness, she was recording the growth and development of a young American family that just happened to be her own. The story is fragmentary. But the purpose is clear. The documentary photographer was still at work."

In 1954–55 Lange assisted Edward Steichen with the selection of images for an exhibition of 503 pictures by 257 photographers from sixty-eight countries. He would include 9 of her works in *The Family of Man*, 1 of them being her 1952 picture of John carrying his first born, Gregor, through the doorway of her Berkeley home. In a deliberate way she continued this practice of representing her sons with their infant children. Three years after Gregor arrived, Andrew was born, and Lange recorded John carefully cradling the baby on his knee and examining him with concern (pl. 36). Andrew, who weighed eleven pounds at birth, had an injured arm. The pregnancy was a difficult one for Helen, John's wife, who remembers how miserable she was that summer when Lange made the shape of the uncomfortable pregnancy a subject for her camera (pl. 37). Three years later Helen would deliver a daughter, Lisa (pl. 38).

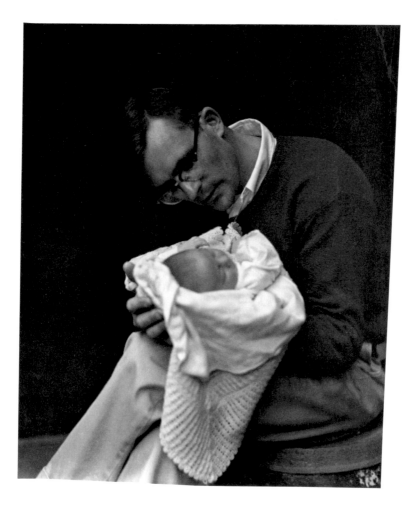

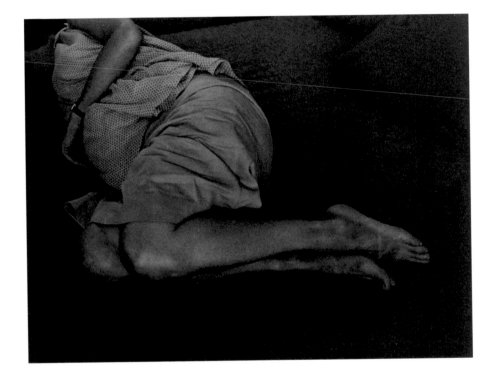

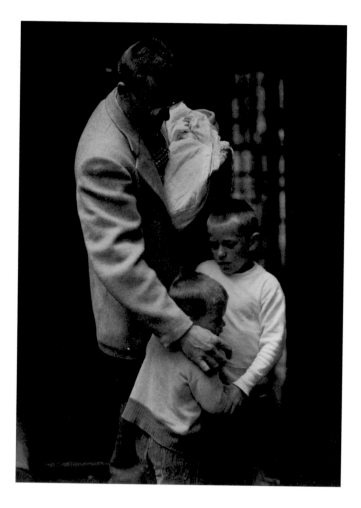

PLATE 39

The Gardener, Mr. Fujimoto, and Gregor Planting Vegetables, Berkeley

1958–59

Gelatin silver print
17.1 × 22.2 cm
(6¾ × 8¾ in.)
2001.34.4

The relationship of man to the land was a constant theme in Lange's photography, at least from the time of her 1930s fieldwork for the Farm Security Administration. She recorded this subject wherever she found it, whether in the San Joaquin Valley, where migrant workers were picking lettuce; in western Ireland, where farmers were digging potatoes; or in her own backyard in Berkeley, where her six-year-old grandson and her gardener were putting seeds into the ground. Labor, the act of working and the peculiar choreography it often involves, was also a continuing motif in her pictures.

In this image Lange captured the forms of the boy and man at their task, bending from the waist to spade and cover. They work in unison, their positions and movements in sync. At the same time, however, there are differences. The boy is smaller, partially unclothed, and uses his hands in the dirt; the larger man wears a shirt, hat, and shoes and employs a steel tool. Lange's eye has collected in this portrayal not only youth and age but also nature and civilization. The subject of family, of a father passing a craft on to his son, may also have occurred to her. If so, she has drafted Mr. Fujimoto, whom she paid to care for her yard, to stand in for Gregor's busy young father and equally preoccupied grandfather. The scene may contain a less romantic message as well. Mr. Fujimoto could be considered a representative of the postwar Japanese American community in the San Francisco area. Having lost their jobs and property due to internment, many of the men turned to landscape gardening for desperately needed employment.

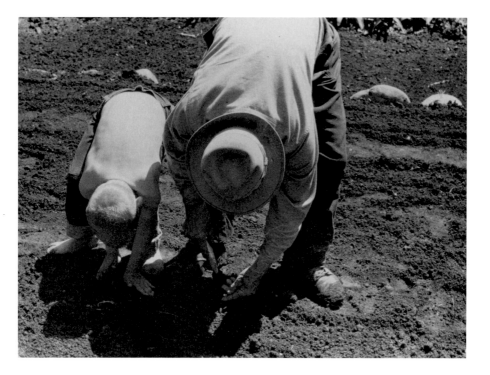

PLATE 40

Codornices Park,
Euclid Avenue, Berkeley
1955–60

Gelatin silver print
10.5 × 15.1 cm
(4⅛ × 5¹⁵⁄₁₆ in.)
2000.43.6

Berkeley in the 1950s was, as it had been for the more than fifteen years that Lange had lived there, a quiet, secure, prosperous town. She sometimes photographed her neighbors on its residential streets, taking a somewhat different approach than the one she used in recording the pedestrians, particularly the women shoppers, in downtown San Francisco or Oakland. The pictures she took close to home include this simple composition, a small representation of a charming scene. The woman, in her plain scarf, dark sweater, and housedress, seems the stereotype of a conscientious young mother. The little girl follows behind, literally walking in her mother's shadow. This pair, observed by Lange crossing the playground in the park behind her house, may have caused her to reflect on her own experience of accompanying her mother on the daily ferry from Hoboken to Manhattan. Their trek, however, was not an idyllic trot through a sheltered, well-kept park. Lange and her mother had to part ways once in the city; each had to walk the crowded, unfriendly streets alone to reach the respective destinations of school and work. Not only the journey, but the act of making it, were painful memories for a woman who had been afflicted with polio as a child. This 1950s family scene was not part of Lange's story, which may be why she could so easily create a fairy-tale-like composition from its sunlit reality.

PLATE 41

Village, Mekong River Delta, South Vietnam / A Saigon Street

1958

Gelatin silver print
18.4 × 24.8 cm
(7¼ × 9¾ in.)
2000.43.13

From June 1958 until February 1959 Taylor and Lange traveled in Asia, returning by way of Russia, Germany, and England. The reason for this extensive trip was his assignment from the U.S. International Cooperation Administration (later the Agency for International Development) to investigate the problems of community development and land tenure in Japan, Korea, the Philippines, Indonesia, Vietnam, India, and Pakistan. His background in the history and economics of agricultural societies made him a popular consultant in the post–World War II era. In the 1950s and 1960s he made frequent journeys to trouble spots, including Cuba, Panama, and Haiti, for public and private organizations. The agency would send him back to Vietnam twice in the 1960s, resulting in several reports, one of which, *Communist Strategy and Tactics of Employing Peasant Dissatisfaction over Conditions of Land Tenure for Revolutionary Ends in Vietnam,* was not released until the summer of 1970.

For health reasons Lange was not able to accompany Taylor on all of his trips, but she was with him in the fall of 1958 and wrote long letters back to their children reporting on his hard work and her impressions of each new country. They stayed in Vietnam for three weeks in a French colonial hotel, the Majestic. Their activities ranged from dinner with the American ambassador to forays into the jungle with government guides. They also had some time for strolling in Saigon's streets and walking along its river, which she described in an aside in an October letter: "Such a fascinating river— to watch its flow and the movement of sampans, and the play of the oars, and the rhythm of the oarsmen is like listening to music; only it's visual."

Although Lange could not record the cafe music that drifted through the rain in this urban scene (loudspeakers were apparently common), she did compose a picture that reflects the graceful movements of a young man who seems to be responding to the sounds of his surroundings.

PLATE 42

Indonesia
1958

Gelatin silver print
24.1 × 33.7 cm
(9½ × 13¼ in.)
2000.43.15

Djakarta was the base of operations for Lange and Taylor while they were in Indonesia. She wrote to Daniel and his wife, Mia, from Java that October: "We are established in a house of our own, in a colony of such; we are air-conditioned. Outside is a beautiful garden with orchids blooming. In runway is a new car. It comes equipped with the driver. Ours. We have six rooms, all open.... We have 5 servants, men in white, women in native dress. All with broad smiles. The cook is a wonder.... All this, you may ask, how come? Courtesy, Ford Foundation!"

Lange seemed to enjoy her time in Indonesia, visiting with royalty, watching performances of classical Javanese dance, swimming in the cold mountain water of jungle pools, and collecting local crafts (masks, sarongs, rice bowls, silk scarves, wood carvings, and Communist posters) to bring back to her family. However, she never forgot that she was a privileged outsider: "We Americans live a role here.

I do not like it, but would not know how to change it. Have been aware of this from the first days in Asia—but here in Indonesia the caste system is really operating." Other of her letters disclose that she chose not to document the extreme poverty of some of the places she visited. Perhaps the numerous images she created while in Indonesia that concentrate simply on feet reflect this avoidance of the harsh environments to which she was exposed.

Lange had long been fascinated by all varieties of legs and feet, whether a stenographer's clothed in torn stockings, a businessman's stepping off a streetcar, or a Burmese priest's posed elegantly in the dust. She even photographed her own foot, misshapen by childhood polio. The barefoot custom of South and Central Asia made it easy for her to return to this favored motif and furthered a more formal, abstract style that became typical of her last years.

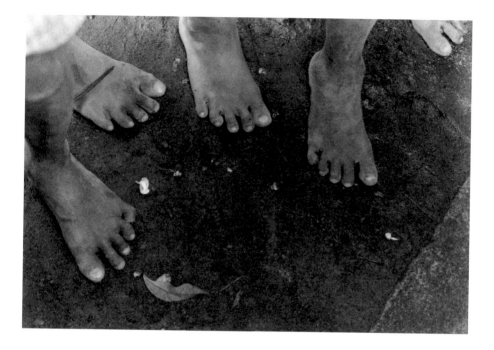

PLATE 43

Sheik and Tribesmen, Pakistan

1958

Gelatin silver print
26.2 × 34.1 cm
(10⁵⁄₁₆ × 13⁷⁄₁₆ in.)
2002.20.2

From Indonesia, Taylor and Lange traveled to India, spending time in New Delhi and Calcutta, then on to Pakistan. They arrived on December 3, 1958, and the next day she wrote to John and his wife, Helen: "Yesterday we arrived in Karachi, Pakistan. Get out the map again. We will be here until Dec. 24th or 25th. On that day we will be on our way again, via Kabul, Afghanistan to MOSCOW! That is, if we can get the Russian visa. The machinery has been set in motion. We will travel by jet from Tashkent to Moscow."

As the days passed, Lange decided that she liked the dry climate and the flat-roofed architecture and wouldn't mind staying on there. In another letter to her family she described, not without humor, the living conditions typical of their travel with the International Cooperation Administration and her own response to the city: "This is Karachi. We live with government friends.... in a gleaming white house about 3 miles out of the city. They have been here, working in Community Development I.C.A. for 4 years.

They are 'good' people. Methodists. Southern Methodists. Grace is said at every meal. This does not fit Karachi.

"We came from New Delhi a week ago. This already seems six months ago. New Delhi is already fading, because this Karachi is a very rough and exciting place. Here are different people, desert people, the beginning of the Middle East. Here is a dry, brilliant country, (after our sojourn in the tropics this is a very great change.) blue and cloudless skies, no trees, and people straight out of our Bible stories. Here are camels used like horses in the downtown streets, and camel trains with jingle bells, camel drivers, covered women, <u>covered school girls</u> even, completely enveloped in a kind of tent . . . who peer out from behind little holes in their head covering."

The men pictured here were part of an assembly with which Taylor conducted business. In a more formal group portrait, Lange photographed them all, with Taylor seated in front next to the senior statesmen.

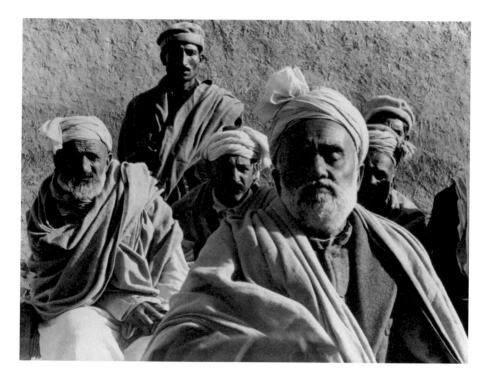

PLATE 44

Egypt
1962–63

Gelatin silver print
26.7 × 33.8 cm
(10½ × 13⁵⁄₁₆ in.)
2000.50.48

PLATE 45

**Khyber Pass
Tribesman**
1958

Gelatin silver print
19.1 × 20.2 cm
(7½ × 7¹⁵⁄₁₆ in.)
2000.50.44

PLATE 46

Pakistan
1958

Gelatin silver print
26.2 × 33.2 cm
(10⁵⁄₁₆ × 13¹⁄₁₆ in.)
2000.43.16

The scarves that Isadora Duncan performed with when Lange saw her dance at the Metropolitan Opera House in 1908 had a substantial effect on the girl, as did Duncan's movements, loose tunic, and barefoot style. Her use of scarves served to highlight or extend her gestures, not to conceal. Lange, however, probably noted the multiple purposes of this feminine device: modifying one's appearance, punctuating one's actions, emphasizing emotional moments. She would exploit the sculptural qualities of shawls and blankets, as did Dixon, when she worked with Native American women in New Mexico and Arizona in the 1920s and early 1930s. Documenting farm women during the mid-1930s, she employed their customary bonnets as a similar framing device to set off the lean Anglo-Saxon profiles and to enhance the suggestion of an isolated, or insular, existence. In the 1950s Lange found the elderly Irish farm women, who wrapped themselves in black shawls, a distinctive subject.

These three pictures, made by Lange in Central Asia and the Middle East, are indicative not only of the way she represented the many "covered women" (pl. 44) she described in her letters but also of her appreciation for the way men in the region might choose to mask parts of themselves in non-Western fashion. In plate 45, for example, a man who no doubt saw battle in the Khyber Pass before Pakistan became a republic in 1956 is so thoroughly enclosed in a wool blanket that only his distinctive "high arched nose" and "expressive" eyes, as Lange characterized them, become part of this anonymous portrait. The traditional "veil" he wears seems a defense against the history, as well as the weather, of this ancient place of constant conflict. Another Central Asian man (pl. 46) improvises the effect of a veil, perhaps more for warmth than style, with a Western sort of overcoat gathered about his head, concealing the shape of his upper body. The ambiguous form of the coat and his anxious, half-hidden face project a sense of vulnerability, the antithesis of the patient confidence of his neighbor.

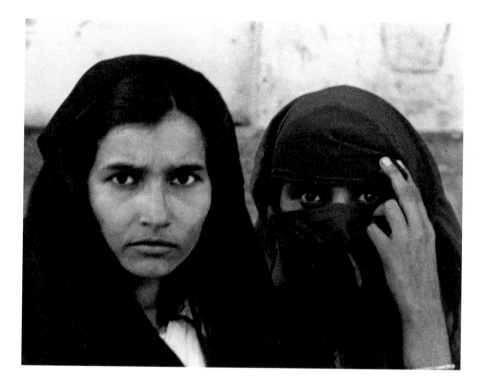

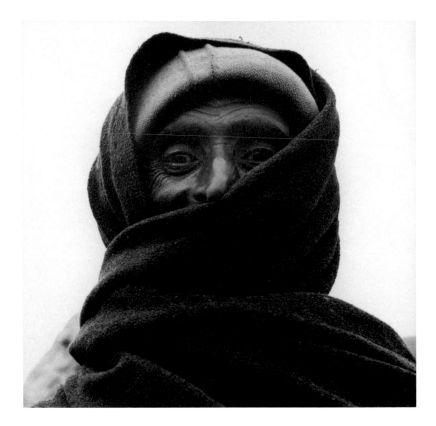

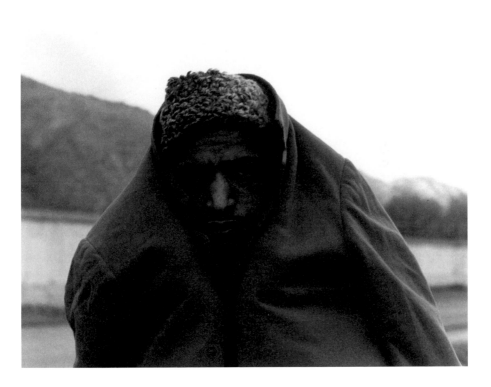

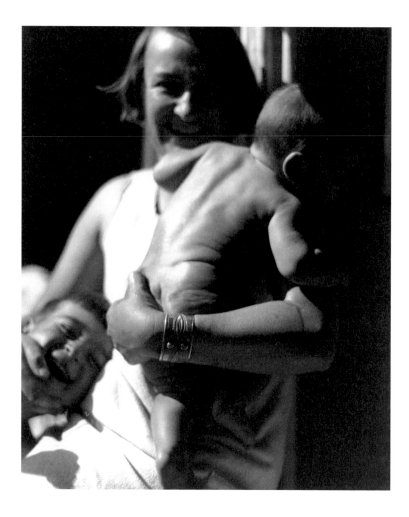

Unknown Photographer.
Untitled (Dorothea Lange with Daniel and John Dixon). Later print from a 1928 negative.
Negative: 10.8 × 8.3 cm (4¼ × 3¼ in.).
Oakland Museum of California, Gift of Paul S. Taylor, A67.137.6717.

Future Evidence:
The Photographs of Dorothea Lange

David Featherstone: Dorothea Lange may be one of the few photographers to have achieved recognition nationally, and perhaps even internationally, through a single image, the iconic *Migrant Mother* (pl. 13). However, she was active for around forty years and depicted a broad range of subject matter through a progression of photographic styles. Today we are going to look at a group of her pictures, some singly and others in pairs, drawn from throughout her career. I invite you to share your thoughts about these images and the circumstances of their creation.

The first photograph we are going to look at today, *Hopi Man* (pl. 2), dated 1926 on the print, was done in the Southwest, which was a favorite source of subject matter for artists at the time.

Therese Heyman: Lange made several images of this man in 1923 that show much more of him; this is a detail cropped from one of those negatives. One wonders when the idea of the detail occurred.

Weston Naef: Does the negative for this still exist?

TH: Yes, the negative is in the archive at the Oakland Museum.

Keith Davis: So this is drawn from a much larger view of the subject. He's depicted outdoors here, but this seems very much in sympathy with the normal working method Lange would use with the portrait subjects in her studio.

WN: I doubt that many of her subjects would have considered this as a commissioned portrait, because there are deep shadows under the eyes and a shiny nose, which would normally be regarded as unflattering to the sitter. I see this as opposite to what she would create in her portrait studio.

TH: The important fact is that she would not have been able to get so close to this person, or to any person. She always dealt with people so that they were comfortable, so this must be a detail. It was not taken this close.

Michael Williamson: Even if you see a face like this that you want, you're not going to get it from eight inches away. Lange probably didn't have the lens to do this anyway. She had to overcome that technical problem, so she previsualized that she was going to crop the image later.

Sally A. Stein: I don't think she knew that she was going to crop this closely at the time. Her credo of a lack of prejudgment and a reliance upon intuition may have operated in a couple of stages, and the stage after taking the photographs would be looking at what she had gotten in her negatives and initial prints and then thinking again about what she might want to do. This is an extraordinary picture, to my mind. Before 1926 we've never seen so close a portrait from her. We don't actually know that she made this print then, but we think it's probably from the 1920s judging from the way it's mounted and the kind of paper it's on.

WN: The reason that I asked whether the negative exists is that my first impression of this picture was that it was actually made close-up.

TH: No, the negative exists with a more distant view.

WN: You know for certain that it's a detail?

SAS: Yes. The negative is a four-by-five-inch vertical. She photographed him in different poses, but they're full figure. I'd say this is only 25 percent of the negative.

TH: Anthropologists are always amazed that people like Lange could ever get this close. Many Native Americans would not permit photography, period, and when they did, even at this later time, they felt that their soul was in some way in danger.

SAS: In 1917 the Hopis had actually prohibited all photography, so it's even more surprising that she made this picture and titled it this way.

Judith Keller: The reason she was with these people, and so close to them, was because of Maynard Dixon and his frequent visits to the pueblos. Dixon's subject was what he thought of as the West, which was really the Old West of the nineteenth century and earlier. He had an intense interest in Native Americans, and I think Lange either absorbed or felt sympathetic toward that. This close-up of the Hopi man's face looks to me like an attempt to capture Dixon's idea of the face of Native Americans. This is the face of the history of that part of the country. It is Lange's personal work, the work she was doing while she was trying to make a living as a standard portrait photographer in San Francisco.

WN: We can conclude, therefore, that *Hopi Man* is a very skillful enlargement from the negative, approximately seven by eight inches, signed on the face of the picture itself, not on the mount. From my perspective, I think the print was made before she relied on assistants. By virtue of the mounting of this picture, which is on a very stiff board, and with the signature and date on the print, this has all the marks of something that the artist herself would have made, and this is testimony to her darkroom skills.

SAS: I'm interested in the comparison with Dixon's paintings and curious if there are any portraits by him that have this kind of radical cropping. I'm wondering where Lange got the idea to cut out all the environment and zoom in so close, not in the photographic act but in the printing/cropping act. It's really quite remarkable, even inspired, and also very flagrant in its violation of normal proprietary distance. This is a completely new kind of portrait idea.

JK: I don't know if Dixon ever did a painting that was such a close-up view of someone's face. I would suggest that she was reinterpreting what he was doing and making her own art out of it. In his almost stereotyped portraits of Native Americans the lines are hard and the features generalized. I think that her way of getting at that kind of representation that would stand for all Native Americans was to do this kind of close-up. The cropping was done later, but her ideas about what she would do with the image were grounded in the original visit.

WN: Dixon's drawings are a valuable comparison to Lange's pictures. In his sketches Dixon took the opposite approach to Lange's. He persistently followed in the footsteps of Winslow Homer by trying to capture, using memory, the effect of an instantaneous action. He would observe a subject in its native environment and try to give an element of spontaneity by appearing to stop action.

TH: Sally's comment about the flagrant use of space and coming so close raises a question for me of when this print was actually made. I am not comfortable with the proposed date, partly because of the print's size. And I'm not yet certain about the signature.

MW: I believe Lange printed this, because I don't think that an assistant would take the risk of cropping so dramatically. This is so far from the original negative that it's just not a decision an assistant would make unless Lange was standing right there giving permission. Of course, since she didn't print a lot, it's difficult to identify a print style that's definitely hers like we can for someone like Ansel Adams.

The crop could have come about, speaking as a photographer, from a desire for a dramatic picture. Sometimes you blow a negative up in your enlarger and say, "Whoa! I didn't see that when I was out there." Many artistic decisions are made in the darkroom; all of a sudden, a possibility that may not have existed in real life shows up right there on your easel. You try it, and you say, "Wow, I don't need the context — that face is dramatic." Lange could have made this decision right at the time, but it also could have come through a willingness to take risks that came later.

SAS: Our idea of what causes a "Wow" changes over time. In the teens, one would not go so close and think, "Oh, wow!" There was a certain moment between 1920 and 1930 when the idea of this kind of proximity with strangers became thrilling, as opposed to bizarre or unthinkable. Lange is in the forefront here, but it is interesting that this is not in a hypersharp New Objectivity style; she's still in a pictorialist mode of softness and warmth.

KD: Part of the narrative logic of this picture is that it is the brilliant light of the Southwest that brings out the texture of the skin. What I was trying to suggest earlier was that Lange began this picture with her standard portrait approach, a half- or three-quarter-length view, but it was transformed into a profoundly radical

picture. I, too, would be astonished if she actually made this print in 1926. She may very well have, but it seems early to me. If she did, why do we see so little else in this vein until the 1950s?

WN: It's possible that *Hopi Man* was printed in the late 1930s rather than the mid-1920s, but this is still long before she began to isolate details of her negatives in the 1960s.

MW: This is an incredibly important picture that predicts what she was going to do, but if she did this in 1926, why not more?

KD: One thing we need to keep in mind is that Lange was a working professional who catered to the needs of her clients, but at the same time she was involved in the bohemian community in San Francisco. She was walking this line between two different worlds. This picture may represent a kind of straying further to one side of that line than she normally did. She never had just one idea in her head at a time. She was a very intelligent, very complex person, involved in a diverse, creative community. But the question still remains: Why is this picture so astonishing, so early, and so lonely, if you will, in her overall chronology?

DF: Let's move from this picture, which, even though it was done outdoors, still reflects Lange's work as a portrait photographer, and look at a pair of prints that demonstrates her transition to a more documentary mode of working. The first is *White Angel Breadline* (pl. 4), from circa 1933; the other is *Waiting to File Claims* (pl. 16), which is dated January 1938.

TH: Roger Sturtevant, who was assisting Lange during this period, tells a story about *White Angel Breadline.* They had similar cameras, and she apparently picked up his when she went out to photograph the breadline. Later, when Roger developed the film, he held the negatives up to the light and knew he had never taken anything that looked like this. He was going to dump them but then realized Lange had used his camera, so he gave her the negatives.

JK: He was working with her in the 1930s?

TH: Oh, yes. Roger started working with her when he was sixteen or seventeen. He continued with her through his twenties. He was her assistant in the shop where

she had her studio. They spent a lot of time sitting around, waiting and talking. When you're a freelance photographer, you don't always have clients, but extra time.

SAS: *White Angel Breadline* represents a major shift for her, because she's going out in the street. This was very much at the beginning of the depression, particularly in California, where it took a couple of years after 1929 to set in. Lange obviously was affected by the depression, as her clientele began to shrink. Her personal life was in turmoil, and her sense of economic stability probably was too. She later said that she created this image "on the first day that I ever made a photograph actually on the street." Sometimes I am inclined to doubt the literal truth of this account as a maiden voyage into social street photography, but this was, in any case, very much at the beginning of her foray into the social world of the depression. This is an amazing synthesis of her ability to capture a single individual in a portrait and to combine that with this extraordinary panoply. It suggests that she was still thinking about individual portraits but wanted to include the subject in a social context of what was going on in the street.

JK: But she isn't yet at the point that she's thinking like a documentary photographer. She picked this man out, so it's like an individual portrait, but the formal elements are more important in this. And she didn't go back to her studio and write a caption for this. She wasn't creating information to go with it; she wasn't documenting the White Angel breadline in that sense.

MW: Which is exactly why this is so important. She was making pictures but not necessarily using the real facts of the surrounding world. Her major objective was to make images that satisfied her creative urge while still being socially concerned. But you're right, she didn't go back and write a caption.

TH: The White Angel breadline is very well documented. It was created as a way to make people who were destitute comfortable enough to get in line, ask for, and receive bread. One wealthy woman—the so-called White Angel—took part in giving out the bread. This was a private endowment to San Francisco's poor that was unique to the time.

MW: There's been debate about the date of this picture.

JK: Right. Is it 1932 or 1933?

MW: Do we now think this is 1933?

TH: I have only Sturtevant to go by, because he documented his own use of the camera. Also a newspaper of the time wrote up the story of the breadline. It preceded the New Deal and was singular, the gift of one woman.

SAS: I would bet on 1932.

KD: It makes a difference whether this was done during the Hoover Administration or in the brand-new Roosevelt Administration.

SAS: I think it's probably around the time of Roosevelt's election.

KD: So you think late 1932?

SAS: The fall of 1932. But it could be the winter of 1933. And, of course, we changed presidents at a later time then than we do now, in March.

MW: This is one of my favorite images. I think it's obvious that Lange had artistic intent, but there's also political intent here. She wanted to take a sympathetic photo in which the rest of America, the viewer, would say, "That is really sad; that is a pathetic situation." This anonymous man might not even be a direct victim of the depression. He could just have been a guy on the streets like we've had throughout history. It really wasn't important. This is about humanity, down in the dumps and hurting. It's a really important picture because she's making a political statement and being sympathetic, yet it's beautiful artistically.

SAS: But it's a very bourgeois iconography of sympathy—make sure you get an individual and yet show that there is a crowd; there's not just one, there's more. And it segues into thinking more socially about class and larger groups. I think her great métier was always focusing on individuals, but here she wants to broaden out, so she combines two scenes, the mass and the individual, brilliantly.

MW: The other bodies are just framing elements. That's the artistic part.

KD: We see all of his face except the eyes, and that makes all the difference in the world. This is the perfect embodiment of her approach—we see a person so pre-

cisely that there's no question that they're profoundly real, and yet they're also symbolic. They're universal. That tension between being undeniably real and being symbolic of a much larger state of affairs is exactly what she did so brilliantly and so consistently.

TH: She thought of herself as having a camera with a purpose.

MW: The anonymity of this man is purely intentional. She didn't want the eyes to show, so she took this from a high angle. And he is different from the rest of the crowd, which includes middle-class men who have fallen on hard times. This is someone who has had hard times before the other folks — he's not of their class. With his back turned to them, he was ripe to be used in this political way.

KD: Part of Lange's genius is that she never pretends to any easy understanding of her subjects. For her, every human being is a very complex, and to some degree, inscrutable, creature. She never provides any superficial suggestion that we understand that person immediately. Typically these faces resist easy understanding.

TH: This is one of the qualities that makes it possible for Lange's work to live and be relevant at many different times. If the work is sufficiently open ended, then it can keep being reinterpreted without losing anything. This photograph doesn't point to a specific time and place in the way that Paul Taylor would have wanted it to, if it were to be a document used to solicit money for migrant camps. What this does is to speak symbolically. We don't necessarily know the identities of many of the people she photographed, but we know that we could recognize the same types today on the streets of San Francisco.

WN: Let's think about *White Angel Breadline* in the context of what was happening internationally. The picture is pivotal because it comes at the very moment before Lange moves away from a formal approach to composition. Recall that in 1929 the celebrated *Film und Foto* exhibition took place in Stuttgart. A number of American photographers were included, most notably Imogen Cunningham, who was Lange's friend, and Edward Weston. *White Angel Breadline* was made three or four years after *Film und Foto,* and Lange certainly would have seen the exhibition publication, because it was sent to the people who were represented in it; it would

have been available in San Francisco. I wonder what possible influence this exhibition may have had on her.

Look at the geometry of the temporary police barricade in the foreground and then at the patterning and texture of the seen-from-behind perspective. This somehow recalls European street photography of the time, the kind of slightly distanced perspective that placed the artist as a divine observer, not a documentarian. It seems to me that in this picture Lange may have been reacting to other photographs.

SAS: I don't fully agree. It is, as you say, a pivotal picture. But as much as there are some suggestions of the radical modernity we see in European photography in the second half of the 1920s, particularly with the barriers, those short diagonal lines, and the fairly strong contrast, it seems so balanced by the single figure at the center. The approach of looking out and finding a pattern interests Lange here, but ultimately she's still holding on to the individual portrait. It's good to point out this European context, but I think she hasn't wholly turned toward that. It's an amazing balancing act as a picture, in terms of compositional formal elements and iconographic subject matter.

TH: This image was one illustrated in Willard Van Dyke's landmark review for *Camera Craft* on her first one-person show.

WN: His review is a thoughtful piece of writing that was surely based on personal knowledge of Lange's thinking. Van Dyke's paraphrasing of her ideas is important to understanding her method of communication: "Miss Lange's work is motivated by no preconceived photographic aesthetic. Her attitude bears a significant analogy to the sensitized plate of the camera itself. For her, making a shot is an adventure that begins with no planned itinerary. She feels that setting out with a preconceived idea of what she wants to photograph actually minimizes her chance for success. Her method is to eradicate from her mind before she starts, all ideas which she might hold regarding the situation—her mind like an unexposed film."

TH: It's interesting that, just a year or two before, Van Dyke had helped Ansel Adams write the Group f/64 manifesto, which is completely different in every way. He was a founder of that group, and here he explains, as a subtext, why Lange was never invited to join them.

WN: The paragraph that I just read is an apologia, so to speak, for the role of intuition in the creation of a work of art. The absence of intention is the diametric opposite of the f/64 approach, where the idea was to previsualize everything.

TH: Someone working intuitively, as Lange did, would have taken many exposures of the same event, and we know she did here. It wasn't until later that she was actually able to say that, of all the negatives she made here, this one best represents what she wanted. You have that opportunity in photography; you don't really have it in any other medium.

MW: Sometimes when I lecture on stories about poverty or social issues, I show a series of photos and point out that there are two types of pictures: the group shot and the iconic image of the single person. Artists, photographers, and writers have always understood the concept that we can tell one person's story, that we don't necessarily need to stand on a hillside and include every single pilgrim who's suffering.

Waiting to File Claims balances *White Angel Breadline.* The earlier photo shows the problem, and here, in this group shot, is the answer. Once the unemployment relief started, fairly nicely dressed men began to appear; just the way they're dressed indicates a little more hope. "This guy in the breadline had a problem, but we're going to fix it and we're going to fix it in great numbers; we're going to fix it as a country, as a group of people." You could do a close-up of a person who's smiling and looking good, but if it's a political statement, you want to say, "We're all getting better as a group." *Waiting to File Claims* still has artistic elements — the high angle and that backlight coming through the window — but the fact is, if Lange had been any lower, the light would probably have created flare and she wouldn't have gotten a good photo. Once again she was thinking both artistically and politically and yet overcoming sheer logistics.

JK: So you think she was photographing from above because of the lighting situation?

KD: Or perhaps to suggest the group as a collective entity? The picture is absolutely about enlightened political—meaning collective—action.

TH: What certainly distinguishes Lange is that her pictures almost always point to a meaningful possible answer that will solve the problem that she's illustrating. She's not illustrating the problem to show you that nothing can be done. She

was able to find a way to suggest in the photographs that there is strength of character available in a person to solve the problem, if not by themselves, with government support.

JK: Yes, there's always this element of hope.

MW: These men are standing in line, but they really don't look that defeated. This is amazingly optimistic for being a group of unemployed, hungry people in line.

TH: That this photograph is from San Francisco, not New York City, is a tremendous difference too.

KD: But this does represent a classic liberal faith that the political system can work. That is, through a rational analysis of the problem, we can have a rational collective response.

TH: This photograph has a specific point of view; there are six or seven versions of this, and they all have this dramatic looking-down viewpoint.

WN: Has anybody examined this series of pictures figure by figure to compare all the hats and coats?

MW: I took a quick look. I didn't immediately see any of the same people repeated, so the negatives might have been made over a couple of hours; clearly they're from the same vantage point. She shot at least a full roll of film looking for variations of the positioning of the figures and the space.

SAS: I want to quibble for a second with what you said, Michael, that we've always known that, if you want to provoke empathy and sympathy, you find a single figure. I think there are various moments when we have known that. Dickens in the mid-nineteenth century. Also Courbet in the nineteenth century, and Hine at the turn of the twentieth century. But for a long time, people in the 1920s wouldn't think about going into the street and looking at the down-and-out in this way. That knowledge was rediscovered or reinvented in the early 1930s. When Walker Evans went to South Street in New York to photograph the men sleeping in the doorway, he was doing this. And Lange was doing it more powerfully right around the same time. She was redeveloping a genre that had literary antecedents—and some from film's emerg-

ing convention of the close-up—but fewer strong social photographic antecedents, although there certainly were some.

MW: I think I meant *always* in the context of photographers who had a political point of view, who understood, for example, how you could rearrange a body in the Civil War to make your point photographically.

SAS: It's so obvious that Roy Stryker sat up and took notice when Taylor and Lange sent their notebooks of California conditions to Washington, because she had figured out instinctively how to describe both the terrible conditions and the possibility for change in a way that was not a pictorial formula that photographers had been drawing on.

TH: I agree that finding the possibility for change is crucial to Lange's work. At the same time, Taylor, who was a modest man, was not eager to show his hand in her work. In a taped interview at the end of his life, looking back, he talked about the research he did for his doctoral dissertation; he went to Mexico to describe the people in a labor program and to photograph. He said that Lange had never before seen someone write down what people were saying and doing at the time that they were photographed. Paul remembered that, by saying to her, "Oh, I've been doing this since the 1920s," he had introduced an idea that may have come out of another field, of research.

WN: What is so remarkable is that for a person who did not apparently write much about her own life, Lange seems to have developed the capacity to record the facts of the people that she was photographing. Reports are that she would work intensely to photograph a subject, then stop everything to talk to the person for thirty or forty minutes to get their story, and then become frustrated because, in the era before tape recorders, she couldn't talk to the person and write the story down at the same time.

KD: The whole notion of influence is so enormously complex. With Lange, I would suggest that the stylistic issues would certainly combine what was deeply inherent in her and, as we see consistently through her career, the specific influence of individual people as well as the demands of the assignments. She was getting paid to make these pictures and produce a certain kind of product. That product is a reflection of her vision, but she was also a true professional. She was living up to the

expectations of her employer in a highly professional manner. That's why she got all the information and provided lengthy captions, whereas with the more personal work prior to that time there was no need to do that. The specific conditions under which she was making these pictures shifted, and she responded, I would suggest, in a very individual as well as professional manner.

TH: Lange had biases; even if *Fortune* magazine was paying her, she was still going to come in photographically on the side of the family farmer, and 160 acres for water, and the need for water to be proportioned. These were biases Taylor fought for all his life.

DF: It was those biases that informed the work Lange did for the Resettlement Administration, beginning in 1935, and later for the Farm Security Administration. They are definitely expressed in the photograph *Rainy Day in Camp of Migrant Pea Pickers, Nipomo, California* (pl. 11), from February 1936.

MW: In light of our discussion that she was a portrait photographer who then went out in the real world, this image seems like a great hybrid of the two approaches. The smoke shows a little shutter drag, so the camera had to be on a tripod. The exposure was at least half a second.

WN: We can see little pools on the water, so we know it was raining at the time of this picture and that the exposure was fast enough to stop the motion of the ripples. And what we're looking across is not a pond, but a huge mud hole. These people must be uncomfortable because it is cold and wet, and they are living in a tent. Yet they have stood to pose for a photograph, which says something about Lange's powers of persuasion!

MW: Everybody had to stay very still; even the kids aren't moving. This picture has a portrait approach with the world as a backdrop—the portrait photographer out there in the real world making a statement.

WN: This image stops time in a number of different ways even though it's a long exposure. It's stopping the time-experience of these people at the moment it was taken, and it's stopping time in the broader sense because we are looking back at this now-vanished moment.

SAS: It's also a fairly specific moment in 1930s California. At the beginning of the depression many Mexicans were expelled from California and sent south of the border. But less than a year before this picture was made, Lange reported that there was a day in the spring of 1935 when suddenly she began seeing a surge of people coming from Oklahoma and the Southwest into California, a new migration. She recognized that as a historic moment, and she was actually quite surprised. For the first time there were migrant workers who were not Mexicans or Filipinos or Japanese, but rather white people who had recently come into the state and were defenseless in this economic climate. They were scrambling for any possible work and shelter.

TH: Taylor's area of expertise was migrant labor, and he understood this situation. In her field notes Lange recorded what people said about being photographed. The comment that goes with *Rainy Day* says, "I don't like you to take my picture because we have shame here." The idea of shame comes up over and over. Or in some cases they say, "Tell the President what's happening; he has to do something for me." The archive of the Oakland Museum of California preserves these field notes.

WN: I think an important distinction can be made between the method used by Taylor and Lange and, for example, that used by Lewis Hine. Hine photographed incidents that he encountered where children were being exploited. He always recorded the names of the people and their ages, but he usually provided his own interpretation of the scene in the third person. He would say something like, "Employed five years, had electricity cut off on such-and-such a date, younger sisters and brothers also working in the same factory." That's very different than quoting the first-person words, as Lange and Taylor did of the people they were interviewing. It's an interesting change in perception.

MW: It's overt politics versus subtle politics. "I'm going to make darn sure you feel sorry for these people that I feel sorry for, and I'll use their words. You don't have to trust me, trust their poignant, terrible tale." Lange knew exactly what she was doing.

TH: Hine even said at one point that he wouldn't be lugging his camera around if he knew any other way to effect the change he wanted. Lange never said that; she assumed that her camera was going to make a difference.

SAS: We can speculate about how seductive she must have been. This family felt shame, and you can see the terrible conditions that have befallen them; nonetheless, Lange was able to get them to go out in the rain and stand tall and pose for a half second. There's a kind of electric attention between the photographer and her subjects across the mud puddle here.

KD: Sally, you're right. Only her personality could have pulled this off. She was having to yell, and yet her charm was still going across the mud puddle, and they cooperated. And she got this image of people who normally would say, "Don't take our picture; I'm ashamed; this is horrible."

TH: Taylor never told her what to take, that's clear, but he may have said, "This is the kind of situation that we're reduced to without government camps." Taylor understood the crucial information.

KD: One of the other things we're responding to is characteristic of Lange—the union of a certain kind of raw fact with an aesthetic sensibility. There's enough of reality that we're shocked, but there's always enough aesthetic sense about the picture to make it memorable. What's so interesting, the more I look at this, is how beautiful those reflections in the water are.

DF: Your comments about this picture have given us a good context for talking about two prints from what has come to be known as the *Migrant Mother* series. But before we discuss the classic *Migrant Mother* (pl. 13), let's look at another image of the same woman, *Destitute Pea Pickers, California* (pl. 12). Although its caption indicates that the family was camped near San Jose, this would appear to have been made the same day as *Migrant Mother*, which we know is from Nipomo.

WN: The caption that says "near San Jose," which was inscribed on the back of the picture at the time of its original publication in the *New York Times,* would appear to be wrong. I believe that this was made in the same location as *Rainy Day* and *Migrant Mother.*

TH: *Rainy Day* was made first, in February 1936; *Destitute Pea Pickers,* in March.

MW: Nipomo is just south of San Luis Obispo, not San Jose.

KD: Someone could have misinterpreted a scrawl.

SAS: Or someone at the *New York Times* could have made an error.

TH: Two of the other pictures from the series of six were published in the *San Francisco News* on March 10, 1936.

JK: Well, *Migrant Mother* and the other pictures in this series were made on the edge of the road, near a camp like the one of the pea pickers, but the people in the pictures were not part of the camp. They had not moved in.

SAS: But it could be the same camp. What the family later took issue with was that they weren't normal migrant pea pickers. They had stopped by the roadside encampment because they were having car problems, so it could actually be the same locale.

KD: Where did the subjects later say they were when Lange photographed them?

JK: They said that they were on Highway 101, just outside of Nipomo. The timing chain on the Hudson broke, and they were forced to pull into the pea pickers' camp. So they did actually go into the camp to fix their car. They had been in the Imperial Valley picking beets and were going to pick lettuce in the Pajaro Valley, north of Salinas.

DF: Perhaps we could consider how *Destitute Pea Pickers* relates to Lange's studio portraiture.

TH: Lange had a talent for finding a special person or a face or a way of moving that has tremendous appeal. When John Ford made the film of *The Grapes of Wrath*, he used people who looked as though they came right out of Lange's photographs. The people she chose have a tremendous presence.

KD: It's a matter of her choosing the appropriate subjects, and the combination of raw fact and aesthetic logic that brings the two together.

JK: In her studio work, one of the subjects she was called on to portray over and over was a mother with her children. She did a lot of family photographs. Sometimes it was fathers with their children. You also see the mother-and-child subject a lot in her FSA pictures. Whether that came out of her studio work or not, I'm not sure, but it was a favorite subject.

TH: The mother-and-child subjects may have come through her own life; she had two children. I think the subject of women and children is one about which women are always expected to be more sensitive.

MW: Part of her genius was picking subjects that seem rugged but handsome. She understood that, if they were too toothless, leathery, or greasy, it wouldn't further her political goal for the viewer to be sympathetic. And if they were too clean-cut, the viewer would say, "He doesn't need *my* help." To ride that edge right down the middle — where the subjects are weathered and hurting, and you can believe that, but you still want to look at them — is really understanding what you're doing.

TH: Lange knew what Stryker expected his photographers to do. She began this series not with this image, but with another that includes a trunk, a whole tent, and an additional child. That image would have had the most information for someone in Washington who had to dole out money for a camp. I've never understood, looking at the six photographs that make up this series, how it was that she was able to move around, wait for, and recognize that moment at the end of the series that reduces all information about the camp, to concentrate on one mother and her children, an iconic picture.

MW: You always have two bosses; you do one picture for them and one for yourself. I do it every day on my job! A wide shoot with the information so that the public at large can understand the who-what-where-when, and then there's this face that I really love and the relationship I've developed, and that's for me.

SAS: Lange is thinking about the public at large, her social scientist husband, her New Deal Washington boss, and about her private self as well. What she was interested in doing was moving between those poles. She tried to figure out how you get that combination of ruggedness and beauty, despair and hope. Even her moving between one husband, who was a solitary, bohemian artist, and another, who had a more programmatic but very humane approach to social science, expressed the poles of her own sensibility and personality.

KD: The *Migrant Mother* series may in fact provide a metaphor for her work in this period. In this series she began with what she was *expected* to do and proceeded along to what she *had* to do, and that spectrum perhaps provides the scale

for looking at all her pictures. Many of them fall at different points along that scale, but—between the requirements and the inner demand—it's part of the same process for her.

WN: Let's return to her relationship with mothers and children. If you isolate the mother figure in *Destitute Pea Pickers* and imagine Lange doing what we saw she did with *Hopi Man* by eliminating the context, we see an absolutely archetypal heroine. But look at the kids. The older one has a strange, grimaced look on her face, and the younger one is being cradled in what would appear to be a rather uncomfortable position. In terms of the physical relationship between the mother and her children, this is really not a poetic statement, because the poses are quite awkward. The expression on the mother's face is spectacular, but the composition itself, with the tent pole cutting off part of the baby's head, is unorthodox.

KD: Yet, if we didn't have *Migrant Mother*, this might have become the iconic image.

DF: How did Lange come to make this series? Why did she choose this woman?

TH: One place we can start in research is Lange's own description, although it changed over the years. She said that she had finished working for the day and had started back home when she realized that she needed to photograph these people. She returned to Nipomo, to this particular group of tents, and from that point she made a series of photographs taken fairly close together. The field notes, which are usually a very good guide, have only a brief comment about this work, not the full page there is for many other series. So this was done at the end of a rainy day as something she was compelled in her own mind to return to do. Call it intuition.

SAS: This was also at the end of her entire month-long job for Stryker. Of course, when you're working for something you really believe in, you never completely close the book, but she had packed up with the idea that she was going home, and I think that may explain why the field notes are so minimal. She was on the way back, but she saw something as she was driving north that made her think that there might be more pictures. According to her account nearly a quarter-century later, she turned around and went back twenty miles.

TH: This picture we know as *Migrant Mother* has interested so many people,

including historians, that there is a lot of conflict about it. The power of the image led to its adaptation for a Black Panthers' illustration, among others.

WN: Let's talk about the Getty Museum's print as a physical object. It has Lange's signature and the date 1936 in black ink at the lower right corner in nearly identical position, ink color, and handwriting as we saw on *Hopi Man*. On the back of the picture there is a Resettlement Administration wet stamp and a long inscription by Lange. As a main title for the picture, she inscribed the words "Human Erosion in California." If this is, as we believe it to be, the closest surviving definitive print, that is, the best print from the time closest to the making of the negative, one would think that "Human Erosion in California" should be the title of the picture. Below, as subtitles, are the words "Facing Starvation" and "Starvation." Then below that, in black ink, it says: "This family had just sold the tent from over their heads and the tires from their car to buy food. The mother IS 32 years old. They were living in an open field, cold and rainy weather, in the hope of getting some work to do picking peas, along with hundreds of other families." And at the lower center, "Photograph by Dorothea Lange for the Resettlement Administration 2706 Virginia St Berkeley, California."

TH: There's a very complex question involved in all of this. The most essential quality here is the tremendous power of the photograph—and this particular print has everything to make it seem as though it's attached very closely to her work—but it may not be her printing. After all, the negative for this was held in Washington with Roy Stryker.

WN: But the inscription is in Lange's handwriting.

JK: Lange supposedly submitted the images of Florence Owens, the woman in *Migrant Mother*, along with other Nipomo pictures to Washington.

WN: The problem is that we don't know how much time elapsed between the making of the picture and the actual delivery of the negative to Washington. The inscriptions are compelling circumstantial evidence for the fact that she held on to this negative for a period of time, because there are no other sources for this inscription. There is no field book, no letter.

DF: A further problem is that the description Judy gave us about Owens and her family doesn't correspond to the information in the inscription on the back of this print. And the "date taken" is listed as February 1936.

JK: My information about Owens's biography and her situation in the winter of 1936 comes from fairly recent sources, like a 1995 article in the *San Francisco Metro*.

MW: Two very important points have been raised here. The first is whether this is the first fine print of this image. And second, was Lange making up the information on the back, or being casual about the facts? If so, that's significant. It doesn't damn her, but it's a significant issue. Don't you think she developed this herself? When she got back to Berkeley, she must have said, "I've got to see this picture." That's why there's a lot of credibility to the idea that the print was made at the time; she knew she had the iconic image, and she put that dramatic caption on the back and titled it *Human Erosion in California*.

WN: Let's not forget that *A Record of Human Erosion* was the subtitle for *An American Exodus*, the 1939 Taylor-Lange book. I would like to believe that the Getty print gave the book its subtitle and not vice versa.

SAS: And that could be an argument for why this title was applied closer to 1938 than to 1936. They were working on the book and were coming up with titles. We do know that she borrowed the negative back at some point, but if they were still using a Resettlement Administration stamp, we know that the print is from before the Farm Security Administration became the official agency.

TH: The Resettlement Administration changed its name in late summer of 1937, but if they were like a lot of offices, they used the old stationery and stamps if they were around.

SAS: It seems to me that this probably wasn't made in 1936, but a year or two later, when she borrowed negatives to make prints for the First International Photographic Exposition in New York, which was in 1938. There was also a related traveling show that followed that was derived from the FSA section of the exhibition.

WN: My sense is that this is, in fact, the definitive print, the best and earliest

surviving print, and that it may have been made between 1936 and 1938.

SAS: I don't disagree with that, but I don't think it was made in 1936. I think it had to ferment and brew a bit.

WN: It had to have a reason—for example, an exhibition—for it to have been created.

JK: The fact that she put such a long inscription on the back suggests that she was sending it to a show of FSA pictures or something about documentary photography, not to some Pictorial Photographers of America salon-type show, or even preparing it for an exhibition of her own work.

SAS: There was a lot of tension between Stryker and Lange about her inclination to think, "Well, these are good pictures; I'm going to send them out because we need publicity on the West Coast." That is what she initially did with the *Migrant Mother* set anyway. Stryker's response was that they were trying to distribute out of Washington and she was creating chaos by setting up her own publicity apparatus out of her home in Berkeley. He wanted to have control in Washington. Her inclination, with Taylor, was always, "We have so many other connections; let us do it."

TH: Lange was an extremely effective woman, which is something we don't always remember since we think of her as being so visual. She was very good at making the connections that needed to be made. Her way of working with Taylor made them an FSA outpost on the West Coast, but they were more than that. They knew more about agricultural economics than Stryker was ever going to. They had better contacts in Washington. Their circumstances were quite threatening to him, and he never got over feeling that here was a woman who was out of control bureaucratically and administratively, who knew how to go around him and get what she wanted from the person above him, and only then would Stryker learn about it.

KD: From a formal standpoint, it's interesting how this has the mother-and-child theme, but at the same time, it has a clear link back to *White Angel Breadline* in the way one central figure is surrounded by faceless, symbolic people. We see

Owens's face clearly here, but there are interesting similarities. One begins to get a sense of Lange's symbolic style, her way of thinking about real people as symbolic entities.

JK: Lange made this woman the symbol of the migrant population when, in fact, Owens wasn't a recent migrant, not part of the wave of migrants from Oklahoma or other Plains states to California in the 1930s. She had come originally from Oklahoma in 1926 and returned briefly to her home state in 1933.

MW: If you look at how dramatically Lange writes the caption, and the heavy-handed title, she knew what she had when she shot it. I wouldn't even doubt that, after she did the other photos in this series, she thought it would be perfect if the kids looked away and weren't such a distraction. Sometimes you discover the best exposure in the darkroom, but I really think she recognized this when she shot it. Even if the woman wasn't an Okie who had just arrived, Lange wanted to make this work a symbolic, powerful image, so she wrote all the drama in.

SAS: I think in the case of both *White Angel Breadline* and *Migrant Mother* that there is a remarkable element of not knowing, of working in the dark and taking a while to recognize what she had. As we discussed earlier with *White Angel Breadline,* she mixed up the cameras, and it was Roger Sturtevant who brought the negative back to her after he developed it. I would argue with regard to *Migrant Mother* that it took her a while—and not only her, but everyone—to come to terms with this image. She didn't really know what to do with it. She sent it out with a group, but she hadn't made a decision that this was the one. It's not her typical pose and distance.

MW: I think she knew it was great. She wrote a caption that says, "This is going to be a great caption for a great photo."

JK: Michael, do you think she posed this?

MW: No. I think they were just sitting there. She had done the alternative versions, so why not try something new? She said, "Kids, if you kind of just look back that way, that would be cool for now."

SAS: She had to do some degree of directing to get this together.

MW: Right. Even to avoid eye contact, she could have said, "Look at where the road is, not me."

KD: I think Sally raises a very important point about the slipperiness of memory and the status of our "masterpieces." For example, it took four years for Stieglitz to show his *Steerage* image in any form. If that was a mind-blowing achievement for him at the moment of exposure, why did he take four years to make it public? It seems to me that Lange may have felt that this was too personal, too artistic, not informational enough. That may be why other images were released first; she may have made this picture for a slightly different reason than she made some of the others.

MW: It might have been too personal to send to Washington, but she still knew it would be a great photo. Once again, she began making the picture she was expected to and ended up making the picture she had to.

SAS: In the 1920s she had a portrait business and there was an art photography scene that she was a part of. In the early 1930s she still participated in an art scene, but by about 1938, for those who really became committed New Dealers, the show was not the thing. It's almost as if the stage had shifted. Photographers working for newspapers and magazines, especially in 1936 and 1937, when *Life* and *Look* began publishing, were not really thinking in the way of a personal vision; in this mid-1930s New Deal period, the personal was being backpedaled. Lange may have been embarrassed that this was so personal and thought maybe no one was going to know what to do with it. Her response wasn't, "I'll save it for something else," but, "Maybe this doesn't conform to the New Deal formula."

KD: But she did make these personal images anyway.

SAS: Absolutely. I think they're very expressive of her real sensibility.

TH: When we talked to Taylor in 1977, he said that, during the FSA days, Lange developed a lot of the negatives and printed them. Part of the reason was a matter of distance between Washington and Berkeley, an administrative matter, you might say, and part of it was her interest in doing something with the negatives in California that she wanted to do.

KD: I don't think we're arguing different points here. The reality is that her motivation was inherently a complex one, and she was trying to satisfy the needs of her employer at the same time that she was, on some level, trying to satisfy her own artistic impulses.

DF: *Migrant Mother* is undoubtedly the most widely known of Lange's pictures, and her photographs during the 1930s for the Resettlement Administration and Farm Security Administration are her most recognized body of work. She continued photographing for nearly twenty-five more years, however, and we want to follow her stylistic development further. Let's continue with this print titled *Amana Society Village, Iowa* (pl. 21), from 1941.

JK: This is one of the photographs she made when she was starting to travel on her Guggenheim grant. She was the first woman photographer to receive a grant from the John Simon Guggenheim Memorial Foundation.

DF: What was her project?

JK: It was to photograph the American scene.

WN: Has anybody seen her letter of application?

JK: Yes. It was very brief.

SAS: Was it so general as the American scene, or was there some specification about older farm communities?

TH: No, the grant text was very general.

JK: She does say something about wanting to record the relationship between people and the land, which suggests farm communities. But what she chose to do, as I understand it, was to go to places like the Amana Society villages in Iowa and to visit some Hutterite communities.

TH: They were what some people called American utopian societies. Not in the Guggenheim application, but later, she became interested in the question of how a cooperative society works within a capitalist society. To me, that kind of question suggests Taylor's thinking.

JK: The utopian societies were all grounded in a communal way of life.

KD: That was an important theme in this whole period of American photography. Paul Strand's work from the early 1930s onward, but especially after the war, is all about premodern societies that have a traditional sense of connection to the land and of strong family bonds. Lange was ahead of this curve, but she was dealing with a theme that became extremely important not long after.

JK: In the 1920s a lot of artists had an interest in utopian communities.

SAS: In fact, it was one of the draws of Taos.

TH: The negative for this photograph is about a third longer on the right, including an open door with a lot of light on it and a window you can see through the doorway. Lange obviously cropped this to focus on the people; they were the subject, not the place.

MW: It changes the picture from being about space to being flat and graphic.

KD: And by taking out the door and information about the couple's house, it went from being an environmental portrait to being a more direct one. It's highly formal and abstract due to the play of vertical and horizontal lines—the black mass against white mass, and the black-and-white clothing of the couple. It's amazingly sophisticated.

MW: The man is probably saying, "What? You want to take a picture of what?" And the woman is probably looking at whomever Lange was with. In photojournalism, we talk about moments, and this is a "moment" portrait.

KD: The feeling here is of an in-between, casual moment. It's almost as if the viewer is a neighbor who has stopped by. We have the sense of a very casual kind of interaction—of people half listening, half paying attention to each other—and that relaxed intimacy plays off against this wonderful, precise, formal vision. It gives this image a very interesting tension.

SAS: For me, this isn't one of her strongest pictures.

WN: You think not? How interesting! For me, it's a visual sonnet.

SAS: I'm intrigued by his gesture, and she's looking off to someone else, whom I imagine to be Taylor. He often stood by and had conversations with people. There's this cross-purpose of attention and focus, but at the same time it's so clearly organized; all the cards are on the photographer's side, and the couple looks unsure of themselves in relation to that.

JK: They're each making a gesture, and that is the sort of thing Lange always wanted. These gestures are more candid than she usually recorded, but the hands and the way they're moving would have been important to her. I think it's wonderful.

WN: Part of the charm here is the sophistication of the formal structure, which to my eye is straight out of high modernism, and the way Lange manages to capture something that is just short of the sentimental. It's so very authentic.

I have to think of this as one of her very best pictures because it recalls Paul Strand, who worked in the 1950s with subjects that were similar — the combination of the human figure with a formalist ground. When I saw this picture for the first time, I couldn't believe how wonderfully touching it was. All those great Westonian textures, and the intersecting grid of different-sized boards. Just imagine it as a Malevich or a Rodchenko, for the formalist-constructivist elements in the background.

MW: Again speaking as a photographer, you can compose a nice portrait easily; you just bring in the light and tell the subjects to look at you. But this is not a portrait, and it even fails as a candid picture because it isn't clear what emotion is being conveyed. Where it succeeds is as a slice-of-life photo, and that is the hardest thing to get. It's different than a candid, because a slice-of-life can just be of an action, like a kid popping a balloon or chasing a cat. This has a kind of fresh innocence because it feels so accidental.

TH: As a couple, Lange and Taylor both had something unique to bring to a situation. If you put Lange's vision together with the fact that Taylor wrote and published a study on utopian communities, you realize that he would have had, without making a great point of it, the information to let her know what was at the essence of this community, rather than what was remarkable on one day. They had an understanding that certainly no other FSA couple had.

JK: Right. She seemed to be off to such a great start with her Guggenheim work, and then a family catastrophe developed and she had to abort the whole project. She had to ask the foundation to keep the balance of her fellowship for a later time.

DF: What was the catastrophe?

JK: Her brother was arrested for defrauding the government.

TH: It was over unemployment, for putting in claims for people who didn't exist. I don't believe he actually set up the system for scamming, but he was a recipient of some of the money, and that implicated him.

KD: There's some irony there!

JK: Lange devoted herself to helping him get through the court case, and that took a few months. That family catastrophe happened, and then the war started and she was called on, first by the War Relocation Authority and then by the Office of War Information.

DF: And of course, on the West Coast, the beginning of World War II was marked by the relocation of Japanese American citizens to internment camps. In the next two photographs, *Interior View of Japanese American Citizens League Headquarters* (pl. 23) and *Pledge of Allegiance* (pl. 24), both from 1942, Lange documented the situation surrounding the relocation.

JK: We think both of these were done in April 1942, before the evacuation actually began. *Pledge of Allegiance* was made at an elementary school in San Francisco; the other, at a Japanese American citizens' center in Centerville.

KD: Although it was before the internment of the Japanese, the sentiment and the racist comments were already in the air. You can almost see Lange acknowledging the politics. The flag picture seems especially political to me.

TH: Earl Warren, at that time the California attorney general, announced the need for what became Executive Order 9066, and then it took months for the government to set up the actual movement of people. The day after Warren spoke, Taylor wrote to say, "Look, this is impossible; this is wrong."

KD: This is a political picture, but it's conflicted at the same time. Lange and

Taylor were obviously against this, yet it was the liberal Roosevelt Administration that was making this bad decision. Since Lange was being paid to document this activity, she obviously would have had very strong and conflicted feelings about the whole process.

SAS: The flag picture is interesting for the way it shows her using head-on flash, something technically we hardly ever see from her. She is also using some of the same compositional techniques we just saw in the portrait of the couple on the bench, and doing it very well. She's trying to be deadpan, but also showing her cards. At this time there were billboards saying, "It takes 8 tons of freight to k.o. 1 Jap," and Lange saw this kind of image as a counter to that, as supporting people who saw themselves as loyal Americans. Could this have been made before she was hired by the War Relocation Authority? Taylor was contributing to some kind of letter-writing campaign protesting this, and certainly she would have had to walk a very delicate line if she was trying to get government work. Do we know whether she ever signed petitions?

JK: I don't know, but she did take the job when the government asked her to document the evacuation. You have to wonder why she would work for a government that was doing something that she and Taylor—or at least Taylor—felt was very wrong.

MW: When you photograph, you slide your politics into certain frames. You get to make your political point, yet you're still doing your job. This picture is saying, "Look, they're Americans! Don't do this," but you could deny that layer of meaning when you turned the picture in to your boss, saying, "Hey, I'm just documenting the Japanese."

WN: For me, the flag picture is successful not just because it says, "We are Americans." It goes beyond that and says, "We are loyal Americans who are as American as apple pie and baseball."

MW: Absolutely. You can see how you could deny its political ramifications, and yet clearly your liberal friends would understand it. *Pledge of Allegiance* is more subtle. It's saying that there are lots of different kinds of faces, but we all still believe in the same country. It's not as overt.

KD: It's ironic, but poignant. The meaning was crystal clear to her, and I think to anyone else who would have seen it.

MW: And you could deny any political angle to it if you wanted to. You could say, "It's cute kids; no big deal," but you could also say, "I'm trying to show that we all believe in the same Pledge of Allegiance; we just look different."

DF: She is also creating a political message by isolating the one girl in the center, just like in *White Angel Breadline*.

MW: You don't point at something that's the most prominent and well-lit thing in your frame by accident.

WN: An issue that fascinates me here is that this is not a classroom full of Japanese American children only. This is as diverse a group as can be imagined! There's a blond, freckle-faced, Anglo girl positioned three heads back, and behind her are other clearly Anglo kids. There are also what are apparently Hispanics and other Asians.

The chief question is, since these two pictures appear from our perspective today to be such effective editorial comments, did anyone see them as such at the time? Were they distributed?

JK: What I have read is that they weren't. Her pictures for the War Relocation Authority were simply documentation; they were just put in a file.

MW: She knew the impact that *Migrant Mother* had had; she knew the sympathy an iconic image can generate. Maybe there wasn't a venue to disseminate this immediately, but sometimes photographers think of photos as future evidence.

WN: Comments Lange made at a later time suggest that she had in mind a general documentation of the Japanese American community. To judge from just these two photographs, you could infer that she had a political agenda and wanted to create works that could change society. I haven't seen the entire body of work; how many pictures resulted?

JK: There are hundreds.

TH: Oakland has a good many of them, but as I understand it, many more were censored and destroyed.

DF: The next two pictures we want to consider were made along the same block in downtown San Francisco in 1945. They are titled *Market Street* (pl. 27) and *Three Women Walking* (pl. 29). This is the intersection of Powell and Market; the Emporium Building is in the background of both pictures.

KD: My memory is that the negative of the first image is square, and that there is a lot of information on the left side of the frame, including another figure. Lange cropped the picture quite radically to eliminate that figure and to make the relationship between the woman and child very explicit. She really emphasizes the space between the two here; with that third figure it's a much less effective picture.

JK: Michael has speculated that perhaps the little boy is not the son of that woman.

MW: Well, this woman looks like she has a very nice secretarial job and might be going out for lunch. I'm not convinced one way or the other whether the child is with her, but she's in one world, and he's in another.

KD: It's interesting to see the full-frame image, because it really speaks to Lange's interpretive act in the darkroom of reshaping—reimagining—the picture through cropping.

MW: She did a great job, because the picture is superb.

WN: What strikes me especially is how successfully Lange, or any photographer, could arrest the decisive moment. André Kertész, as we know, was exceedingly rational on the one hand but intuitive on the other. His photographs look intuitive, but when you get into them, you realize they were previsualized. When we gaze, for example, at his pictures of the steps of Montmartre, with the figures caught in motion down below, we realize that he had set a trap. He knew that something interesting would eventually pass by.

MW: Photographers still use that technique today. We find an incredible alley with brick and water and just hope some hobo with a shopping cart, or a bicyclist, or a

pigeon comes by to finish it off. It's hard enough to find a great palette like that and wait for somebody to throw in the paint for you, but pictures like these from Lange are the toughest kind of photography. Out in the street here, she couldn't control anything, yet the picture is so clean it looks like she did it with a slide rule.

WN: Yes, Michael, you are so very right. Actuality is not easily harnessed.

MW: It is amazing for a street photograph to have this freshness and clearly be done on the fly.

JK: Michael, do you think that this happened because it was Lange, a woman, photographing these women? Rather than avoiding her or getting flustered, the subjects just look at her?

MW: Absolutely right. If it were a man, the response might be, "Hey, who are you? What's your deal? I don't know you!" Anybody who says that men and women can do street shooting the same way hasn't tried it.

WN: As David said, these two pictures were made along the same block. Is there any reason to think that they were not made on the same day? Or is this possibly a place that Lange returned to habitually and made many pictures because she knew the parameters?

MW: The light is pretty much the same, almost identical. I'll bet the negatives are on the same roll.

SAS: Lange was very interested in shopping. We know from her correspondence with Edward Steichen in the 1950s about ideas for *The Family of Man* that one of the image categories she suggested to him, along with other various sociological groups, was shoppers. He didn't end up including it. In *The Family of Man* people get married, make love, have children, go to war, make peace. They don't shop. If Lange had been organizing it, she might have thought that, to be emblematically modern, the exhibition should also deal with all our consumer desires as well. Had she not had such chronic and recurrent illnesses in the 1940s and 1950s, one can imagine her spending even more time on Market Street or in downtown Oakland really trying to see how the world was reorganizing itself to be flagrantly consumerist.

JK: *Three Women Walking* says more about shopping because two of the subjects have bought something.

KD: Lange was definitely interested in issues like the new economy and consumer culture. To me, these two pictures suggest the range of her interests. She positioned herself on that street to record passersby holding new purchases, but she was also clearly interested in the various permutations of human relationships between generations or in this poignant gap between the woman and child. There's an elegance and a sadness all wrapped up together in that picture that is very autobiographical. This disconnection between the self-possessed, proud, intelligent young adult and the child, who is in another world, says something about Lange's own situation, I think.

WN: There is a distance there, a separation, that I find quite peculiar.

KD: Yes, but the point of the picture really *is* the gap between the figures.

MW: Normally it would be dangerous to speculate on something so heavily symbolic, but Lange cropped the photo to make this statement, so you're not off-base at all in suggesting it. This was a very intentional act when she shot it, and she really tweaked it when she cropped it. She left room for us to look at this and say, "Hmm, interesting disconnect here. Are we feeling guilty in our later years?"

TH: When the Oakland Museum reprinted *An American Exodus* in 1969, Taylor very specifically wanted us to put in photographs representing the new economy. He really wanted it to have that extra section, for which, of course, we were roundly criticized. But the book does have a lot of photographs from this period that have the feeling Taylor wanted to get across about what happened after the war.

DF: Comments about Lange's relationship with her family have been made a number of times today, and the next two prints will let us explore those issues in a multigenerational way. The first picture is *Maynard Dixon and His First Son, Daniel* (pl. 1), from 1925. The other is *John Dixon, Daughter Lisa, Sons Gregor and Andrew* (pl. 38), which was apparently done in front of Lange's home in 1958.

SAS: After doing a fair amount of work on *Migrant Mother,* I want to call these Lange's "Padonna" pictures. I think she was a great photographer of fathers and

children, and we see that early on in this picture with Dixon. Who could want for a more nurturing dad than this? He's showing off his custom cufflinks with the thunderbird insignia—very fashionable, very bohemian—but he's incredibly tender here.

WN: The way Dixon is cradling that fragile infant arm with his left hand is a very tender gesture.

SAS: The baby is just sitting down, slightly falling over, but he fits securely on the arm.

TH: In these pictures I think Lange is depicting a sense of the family she didn't have as a child growing up. These family moments took on an enormous significance for her; each time a child was born, she required the family to come to her and present the child, then she took a photograph. It was the same with holidays; everybody came to her home for Thanksgiving.

What's interesting is that John Dixon, Lange's second son, who is in the second photograph and who sold this print to the Getty Museum, made a tremendous scene when the Oakland Museum used a picture of his hand and daisies in an exhibition. He said it was too intimate, and he didn't want us to use it. So the fact that he has shared this one with the Getty Museum shows how much his life has changed and how much more able he is to appreciate what his mother was doing for him, which he never recognized during her lifetime.

WN: John is the younger brother of the child in Dixon's arms. It was about seven years after John was born that Lange and Taylor established their relationship.

TH: They married in 1935, but they met in 1934.

WN: Did Dixon leave Lange for another woman, or did Lange leave him?

TH: She left him at a point when he was less able to find success in his own work. He was quite ill with a lung disease that bothered him terribly, but she had met someone who closely mirrored her interests. Taylor was a brilliant but modest academician whose ideas were well formed and whose sense of values was liberal and humane. And Dixon, of course, was this bohemian, warm, enthusiastic, loving person who drank a lot and had a great time; he was always willing to be an icon-

oclast, to insult the rich donors. The contrast in the two men is quite striking, and the children probably recognized that throughout their lives.

WN: And Dixon only lived about ten years after the marriage dissolved.

JK: Yes, he died in 1946.

TH: He got married again, to a very nice woman who cared a lot about him, Edith Hamlin. As an artist I think you're fortunate if you have either a wife who is willing to keep all your records or a husband like Taylor, who took every published article about Lange, bound them in books, then gave the collection to an institution. He made sure the children didn't get to keep the rights to the photographs, because he could see far enough ahead to know that if they had the kind of complex family relations that Lange had, her work would be dispersed and the copyright would be completely diffused.

JK: Even though the picture of Dixon is a quintessential scene out of the life of a bohemian family, and the other is quintessentially 1950s, they have a lot of similar elements—the prominence of the father's hand, and the right arm looking large and strong and protective.

MW: We know now that men can be soft and fuzzy and wear sweaters and be babysitters while Mom goes off to work, but there was a time when you were some kind of wimp if you did that. What I particularly like about the photo of Dixon is that he's not just holding Daniel, he's whispering in his ear, doing a little bit of comforting. There's a very similar sentiment with the picture of John and his children, which is a strangely intimate photo. We always think of intimacy as doing things like hugging, but sometimes it's just a touch that says, "I care." Maybe John was trying to separate the boys or get them to pose, but he's in control. He's got the baby in hand. It's surprisingly intimate, but not in the traditional way.

JK: The Dixon image is very much a picture of the form of the baby's body and what babies' bodies can do that adult bodies won't do. All during their childhood, Lange seems to have photographed her sons in the nude; sometimes they're playing, but other times they seem to just be at home sitting next to their father while he reads to them.

MW: Artists don't have an on-and-off switch. You don't shoot cheesy candids of your kids and then go out in art mode. Speaking from experience, I don't really have plain pictures of my children. Even though I'm just documenting daily life, I'm shooting for a portfolio picture too, because there just isn't an off switch. I agree that this is a nice candid photo of father and child, but the art is a subconscious thing that comes through when you push the shutter. I'm sure Lange was aware of getting a nice photo that would be artistically pleasing.

The other picture is more a slice-of-life image. Wearing light-colored clothes in the hot overhead light is not conducive to having light on the face; this has everything going against it, except that tender moment. Moments of intimacy are so powerful because they overcome bad compositions and bad lighting. Photographers wake up in a cold sweat thinking about shooting in light like this, but the photo is there because of the moment, not the artistic light.

DF: I almost feel as if this had been intended to be much more formally structured than it turned out to be, possibly because the younger brother just wasn't in the mood. It may be a better picture because of that.

MW: But Lange was smart enough instinctually to shoot what was there.

WN: What you say is important; the picture resulted from the power of intuition, not from the purely rational seats of the mind.

JK: But she apparently couldn't persuade Steichen to include more pictures on the theme of fathers and fatherhood in *The Family of Man*. She obviously felt it was important, and *First Born*, her wonderful picture from 1952 of John with Gregor, was used, but it was one of very few. I wonder if the reason there were any pictures of fathers included in *The Family of Man* was Lange's doing.

SAS: I very much think so.

TH: You have to remember that Lange is the mother of Dixon's baby and the grandmother of this family. If you're seeing a baby for the first time, would you stand there and make a photograph or would you go over and hold the child? This is what her kids constantly bring back to memory—she took the picture; she didn't necessarily embrace the people.

WN: It is probably no coincidence that, as I recall, there are no Lange pictures of Daniel and John at the same ages as her grandchildren here. The reason may be that she was busy doing other things.

JK: She did make pictures just of them, but not of them and Taylor.

DF: Another family picture is *Helen Pregnant* (pl. 37), from 1955.

JK: Helen was John's wife.

DF: And the mother of the three children in the family portrait.

JK: Yes. She is pregnant with Andrew here.

TH: John and Helen lived next door to Lange and Taylor on their land. Their house had been Lange's studio and then was given over to them when they really didn't have any other resources.

WN: Helen ended up being the heir of Lange's studio and lives there now; the rooms still have some of Lange's memorabilia around. I think that tenderness and close proximity is clearly expressed in this picture; it somehow speaks louder than any words could about the high regard of one person for another.

SAS: Lange may have been close with her daughters-in-law, but she photographed both of them in a bit of trouble. I don't want to overly pathologize this pregnancy picture, but the way it's cropped here makes it look like a body without a corresponding head reigning over this condition. I think it's a very troubled vision of what women face. When you think about the portraits of Maynard and John as active fathers, in some ways Lange gives a more hopeful, purposeful vision of the possibilities for men.

KD: I agree with Sally here. To me, this picture has always been very moody and bittersweet. It suggests the physical toll that the creation of new life requires—that it sucks away at one's energy and stresses the body and the mind, that there's a price to be paid.

MW: I agree with you both. I think this is a really sad picture. Here she photographed her own relative in much the same way she would have shown the migrant

mother if she were to crawl into the tent and go to sleep. But remember that Lange was sixty years old when she made this; you shoot a different way when you're feeling older and tired. The negativity just creeps in, and you don't even know where it's coming from.

WN: I disagree completely with your interpretations of the picture. What a miracle that this very pregnant woman retains a sensual aspect! I see this as a miraculously tender picture.

JK: The discomfort can be great when you're that pregnant. She's eight or nine months pregnant, and it's summertime; she has on a sleeveless dress and was wearing sandals, so you can infer that it was very warm. You just really don't feel like moving around. Your ankles are swollen.

MW: This doesn't have a look of celebrating pregnancy to me.

KD: I would just repeat that I see it as a very moody and bittersweet picture.

WN: The word *moody* I would agree with as an adjective, but to me it doesn't have a negative denotation.

KD: It may be a tribute to Lange's artistry that this picture can evoke related but still very different responses.

DF: The final picture we are going to look at today is a composition made up of feet, titled simply *Indonesia* (pl. 42). It's been dated to 1958 and was done on one of the overseas trips Lange made with Taylor.

SAS: Photographs of feet occur frequently in Lange's work, and noticing this has led me to do some thinking about what's behind her fascination with them.

TH: As a help to Sally, who has been such an advocate of what it is about the body that Lange was interested in, I searched our computerized catalogue of the collection to see how many photographs Lange made of feet. The answer is about 210.

SAS: If you think back to the 1940s shopping pictures, most of the women have on high heels, which Lange never wore herself and was fascinated with. I think she was intrigued with all manner of bodily forms, with perfection and aberration, and

with what is aberrant in one context that may be the norm elsewhere.

It is interesting that in pictures like this we lose all documentary sense of place. From the picture, you haven't a clue where you are. But Lange was really interested in how we ground ourselves to the earth, in a very literal, concrete way, and she thought she had a right to look at these details as someone who had limped all her life after contracting polio as a child and had been embarrassed about her right foot. Only late in her life did she share that feeling with students. In the late 1950s she gave them an assignment to photograph something they hated. She brought in a photograph of her foot and said, "I've hated this my entire life."

KD: Each one of the feet in this picture has a real personality. We know that each one represents a real person. It is through the feet that humans, with all their spiritual longings, contact the ground. I think she's seeing feet as an emblem of identity. Every one is different, and you can see signs of distress, of scarring, of even distortion in some of the toes. These are parts of the body that have endured. They've been misshaped, they've been stressed and strained, but they endure, and they sustain us.

I think this is very much about the cycles of life. I love Lange's late work, which I think has not been generally given its due. Her late pictures are profoundly important to an understanding of who she was as an artist. Zeroing in on intimate little details and completely ignoring social and historical context is what the late work is all about. It's her profound vision of some grand, universal, human condition revealed, ironically perhaps, in these almost microscopic fragments of reality.

MW: I disagree slightly. We photographers have a running joke when we go out to shoot feature pictures—when there's no content, go graphic. That is, get a pattern picture of the bleachers.

I think Lange might have been attempting, with this picture of feet, to really symbolize the Third World—the laborer's foot, like the weathered Indian face that says it all, that is the window to the soul. But there's not enough scarring or calluses or texture in the feet to give me the information that addresses something that could be sociologically revealing. It's not that brilliantly composed of a graphic photo either. I know exactly what she was reaching for, and I feel where

she was coming from. It just comes up a tad short for me.

TH: There's one of those universal children's games where everybody stands and puts one foot forward. The way in which these feet are all put forward here reminds me of that.

JK: There are two things that come to mind about why Lange made this picture. One is that she was happy that, in this country where she was visiting, and probably in quite a few that she visited with Taylor between 1958 and 1963, the custom was for people to go barefoot. She had all these amazing feet to look at and to photograph all the time, so she made a lot of pictures of feet during those trips.

The other thing it makes me think about is the fact that she was very restricted on some of those trips in terms of where she could go and what she could photograph. She didn't like that at all; it was very frustrating for her. One of the few things she probably could do was to walk past people on the street or stop to look at groups of kids. This kind of subject isn't complicated or newsworthy, but it's one that was available to her. It was formally interesting and a subject she had been fascinated by since she was young.

DF: Lange may have been glad to have access to so many feet as subject matter, but I would take issue with your statement that these people live in a place where it's the custom to go without shoes. My reading is that they don't have shoes. These are clearly children's feet, but they are also feet that have not been inside shoes very often.

I get a sense of vertigo looking at this picture, and it's more than the fact that the camera's looking down. Something about the vacant space between the feet draws me into the picture in an uncomfortable way.

SAS: What you'd expect to come up from the lower edge is the foot of the photographer, but it's not there.

DF: Yes, exactly.

WN: Are these children's feet? They look like they have seen a few miles. Look at the foot in the middle. The toe next to the little toe is so gnarled that it has to have been molded into that shape by years of hard work. I can feel every hour that these

feet have toiled, how physically demanding the life is that these feet suggest.

KD: I think this is a very important picture and that Weston's comments are exactly right. What we presume is going to be a whimsical or casual picture is actually a profoundly philosophical statement about the nature of the physical body and the transience and hardship of existence.

It occurs to me that few of Lange's late pictures have captions. They don't need them, and Lange didn't intend for the images to have captions, in part because what they actually communicate is extremely hard to put into words. This was part of her career trajectory. One could say that her early commercial work was very simple in a social, professional sort of way. The work of the 1930s is more complicated, dealing with political and economic issues. At the end of this trajectory, there is a new kind of simplicity that is profoundly universal and, in a sense, beyond what words can express. Not to overdramatize the point, but pictures like this one convey a feeling about human existence that is tough to sum up in a caption.

SAS: I would like to pick up on David's comment about the vertiginous feeling he experienced looking at this picture. It's true that she was after these extremely distilled, simple, beyond-words universal thoughts and images, especially in this overseas work, but also in the domestic work, like the photograph of Helen we looked at. I think sometimes she was straining too hard, as Michael suggested with this picture. I commented before that what's missing here is the balance from below of having her foot stick in. All these feet are coming down at us, even though, in another way, we're looking down on them, but in the flat field of the picture plane, they're coming down at us. I think it expresses her mixed feelings, whenever she was abroad and struggling to photograph, of never being fully legitimized as a photographer, being seen more as Taylor's wife, but trying to be serious about returning to photography and working abroad. She was very aware of wanting to make universal statements that extended the idea of *The Family of Man*, and she was also aware of how privileged she was to be an American traveling abroad, especially under the aegis of agencies like the International Cooperation Administration. On the other hand, she found it frightening and alien; she often recorded in her journals being repelled by the dirt, the filth, the brutal, bare, subsistence level of living.

I think this picture tries to juggle all of those feelings, of wanting a direct encounter but not putting out her own foot, and of being aware that this isn't a relationship of equals. It leaves us with something that's manifestly sweet and innocent but formally unbalanced; it may be socially vertiginous, even if it tries to be the ambassador of goodwill and universal feeling.

WN: Vertiginous is an excellent description of this picture. I literally felt dizzied by it.

TH: For me, Lange had amazing accomplishments as a photographer. She produced all of the different meanings that have emerged in this colloquium. None of them are ruled out. Something that I find mystifying relates here. Lange continued to be self-conscious about her deformed foot. She said, "Every day is marked by my feeling of limping and not being whole."And yet people who worked with her, some of them for several years, did not know that she limped. There's an extraordinary disconnect between what the photographer understood about herself and what others perceived about her.

WN: When I reviewed Lange's body of work made in foreign places, it impressed me as being good because it is spare. She really picked her subjects, and the ones that she chose couldn't have been photographed by just any tourist.

KD: This late work has been put down because, supposedly, there's not enough of it, it's too sporadic, we're not really sure what she's getting at, etc. But I think it's a great heroic, poetic achievement and a perfect distillation of the core issues she dealt with over her whole life. Of course, a picture like this needs to be seen in the context of the many others she did of feet and the very celebratory images she made of the human body as a vehicle for transcendent expression. The late work has all those elements: that bittersweet sensibility, the earthiness, the evidence of pain and suffering and labor, but also our ability to transcend the merely physical and to create moments of profound beauty.

MW: Maybe this late work is a kind of pure Lange in that she was not burdened by needing to make a political statement or to please a boss. She didn't necessarily have to worry about secondary motives. She shot what she liked and what interested her at the time, and what interests you later in life is a lot different and some-

times less complicated than what interests you when you're younger.

SAS: When you read her overseas journals, though, she was enormously burdened.

JK: It was hard.

SAS: Worse than hard. She was tortured. She questioned herself every day. But I think something interesting comes out of it that is not fully resolved. Pictures like this attest to her thinking about it and realizing how much she would like to connect and how truly impossible, especially in alien circumstances, it is to ever really connect. And yet that was her goal. She spoke about the aim of the visual life that she wanted to live, and she thought photography might both emblematize it and make it possible, yet trying to live it overseas, I think she was compelled to question it.

KD: I would suggest that, for her, travel was symbolic of existence in the sense that existence itself is about *not* connecting, about the real difficulty of knowing who we are or how to connect with others. It's about discomfort. Those issues were magnified tremendously when she was overseas, but I honestly see her late work as a statement about universal human existence.

TH: I think that is a powerful way of seeing her work at the end, because so few people have given it that kind of overwhelming analysis.

KD: Well, not everyone agrees!

SAS: Most people don't.

KD: But I truly do see this late work as heroic. In these small, intimate images she is whispering great, profound statements to us. Does this work have the depth in numbers of her 1930s photographs? Of course it doesn't. But I think these are deeply felt pictures.

JK: The problem is we don't know very many of the pictures.

WN: Even though there may be other surviving negatives, I think it would be a mistake to search through the files to try to create our own personal "masterpieces."

KD: Exactly. This is her statement, and that's what we have to go on. It's a very finite, limited statement compared to the 1930s work, but each of these pictures meant a lot to her.

JK: Obviously, if she had lived longer, she would have printed more of them, but because she got involved in the planning for the MoMA show in 1964, she really didn't have the time to think about the work, go through the files, and make other prints.

DF: We normally close these sessions by asking the panelists to make a few final remarks, and I think that process has begun in the past few minutes in a very fascinating way. So to conclude, perhaps you can each give us a brief reflection about the discussion we have had today about Lange and her work in photography. Judy, do you want to start?

JK: Thanks, David. Documentary photography was at its peak in the 1950s, in terms of both the public recognition of it as something valuable and museum recognition with such shows as *The Family of Man*. Looking closely at Lange's work now reminds me that it was incredibly beautiful but also very meaningful. Her intentions were to record something that was actually happening, to depict real events and to collect the information that went with them, so that we have a record. She did that better than just about anybody else during her lifetime. I'm also reminded of how important documentary work is, period. Lange's work is certainly significant, but continuing this kind of work is also important. It should be given more support and attention than it is now.

TH: I think of Lange as a creative talent made humane by her life's early experiences who documented the world as a continuous self-portrait, experimenting, changing, moving about, hard as that may have been for her. Her work is complex and open to many interpretations. Hers are iconic images through which each new generation is moved to contemporary reaction. Audiences can still follow her intent.

MW: I'm going to bring up Walker Evans, because he was also an influence on me. If you could say Evans was a little cool, Lange was warm. Evans liked buildings and cars and signs, inanimate objects. When you view his work, you're more likely to say, "Man, those were the good old days. Wouldn't that old Coke sign look good

over at the Cracker Barrel?" With Lange's pictures, you don't say this, because you see people, you see pain. The adults I knew in my childhood were defined by the depression, and I was always very curious about that time, about the amazing events that we'd hear about around the table.

I have more appreciation for Lange now than ever, because to skirt the edge of being sentimental and close, emotional without being ridiculously schmaltzy and forced, was amazing. She really did care. Like all of us, she probably wasn't very objective, but she didn't go so overly political with her thoughts as to make her pictures reek of propaganda and make you turn away.

One of Evans's subjects in *Let Us Now Praise Famous Men* particularly disliked the pictures, saying that they froze the individuals in time. The people changed immediately after Evans was there, and yet they were frozen as pathetic symbols of poverty in every museum and book.

What I like about Lange was that she changed. She changed her outlook on life. She changed the way she cropped her photos. She changed the context as she grew. And because the pictures are warm, I think that those people aren't as frozen as they might be in some of Evans's. Even though she was a portrait photographer, real life is in there because there's still dignity and there's still hope, even in the saddest photos. You don't give up when you look at her photos, and yet you still have a very good record of how hard it was. That was an amazing feat she pulled off.

KD: I think it's clearer than ever that Lange's achievement is absolutely monumental. It was a hard-won achievement. Nothing came easy. Her life was not perfect. She was not a perfect human being, but she was a brilliant human being who achieved amazing things in ways that we still haven't quite come to grips with. I think she remains a very easy photographer to underestimate and to misunderstand.

Lange transcends the idea of documentary photography. I think her work raises to a very high level the tension between fact and interpretation, the tension between being a professional and expressing a personal vision, of recording fact and deliberately creating symbols. Her career had a grand trajectory, and that whole trajectory really means something—the early work, the great midcareer work that everyone agrees on, and the later work that is more up for debate. But the trajectory itself describes an increasingly personal investigation of what her

life, and all life, is about. For her, fundamentally, that life was profoundly compli-
cated. She was not sentimental. She understood that good feelings are a part of life
and that tough, complicated, unpleasant feelings are a part of life. And it's that
holistic, rich, complicated vision of the human condition that I think is going to
have relevance for every generation to follow.

SAS: When *Let Us Now Praise Famous Men* came out, I think it was Lionel Trilling
writing in the *Kenyon Review* who said that if there's any weakness in the work,
it's that there's no vision of a capacity for evil, that the resulting depictions of these
people are too innocent. Trilling in 1942 focuses on James Agee's text, but he does
not exempt Evans's photographs from the charge. And yet we continue, often, to
characterize Evans as cool and Lange as warm. Indeed, this sort of gendered, ther-
mometric comparison has persisted from the 1930s into this century. But what
continues to compel me about this work by Lange is how philosophical it is as an
investigation into the power and complexity of vision. This idea of the visual life
was believing that vision might speak as well and as complexly as words, and that
it may have its own limits that themselves need to be investigated. I think her work
continues to push against what it is possible to see, to capture, and to compre-
hend—and to recognize also that there are limits.

WN: One of my personal beliefs is that artists are licensed to behave and act on
the basis of instinct. It seems that many of Lange's photographs are the product of
this. My reverence for her work is based upon my great admiration for her power
to harness instinct.

Michael talked about how Evans and Lange expressed admiration for
times past, and that brings to mind my favorite quote of Evans. He said it in 1961
but probably thought it many years earlier, but had not written it down: "I was and
I am interested in what the present will look like as the past." Surprisingly, Van Dyke
concluded his first piece of critical writing on Lange with the following words:
"Perhaps we can arrive at a better evaluation of her record in terms of a future
observer than as contemporary critics. We ourselves are too poignantly involved
in the turmoil of present life. Much of it is stupid, confused, violent, some little of it
is significant, all of it is of the most immediate concern to everyone living today —
we have no time for the records, ourselves living and dying in the recording."

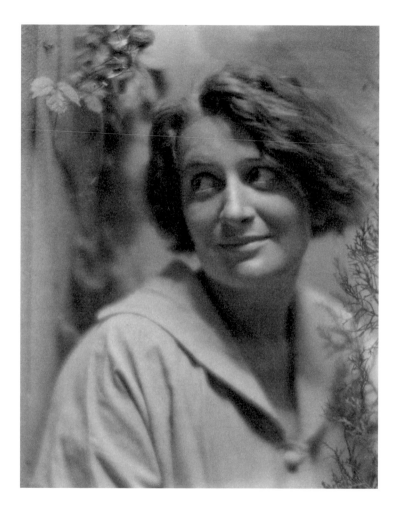

Edward Weston (American, 1886–1958).
Dorothea Lange, 1920. Platinum or palladium print, 19.7 × 15.3 cm (7¾ × 6 in.).
Center for Creative Photography, The University of Arizona, Tucson, 76:005:023.

Chronology

1895
Dorothea Margaretta Nutzhorn is born in Hoboken, New Jersey, on May 25 to Joanna Lange and Henry Nutzhorn.

1902
Contracts polio, which results in a malformed right foot and a lifelong limp.

1907
Father abandons the family, so she; her brother, Henry Martin Nutzhorn (b. 1901); and their mother move in with Dorothea's maternal grandmother, Sophie Lange, and great-aunt Caroline. Attends P.S. 62 in Manhattan.

1908
Sees Isadora Duncan perform at the Metropolitan Opera House.

1909–13
Attends Wadleigh High School for Girls in Manhattan.

1913–14
Graduates from high school and enrolls at the New York Training School for Teachers. Decides to become a photographer and begins working in portrait studios, including that of Arnold Genthe (1869–1942).

1915–16
Works in the studios of Aram Kazanjian and Mrs. A. Spencer-Beatty.

1917
Takes a photography course at Columbia University taught by Clarence H. White (1871–1925).

1918
Leaves New York with a friend, planning to travel around the world supporting herself as a photographer. Due to a robbery, however, the trip is aborted in San Francisco, where she settles, working as a photo finisher and joining a camera club for darkroom privileges. Establishes a portrait studio at 540 Sutter Street. Formally assumes her mother's maiden name. Meets other artists, including Imogen Cunningham; her husband, Roi Partridge; and Consuela Kanaga.

1919
Meets the artist Maynard Dixon (1875–1946). Carmen Ballen's article "The Art of Dorothea Lange" appears in the December issue of *Overland Monthly.*

1920
Marries Dixon on March 21. They live, with his ten-year-old daughter, Constance, at 1080 Broadway, San Francisco.

1921
Dixon reduces his commercial illustration work to concentrate on painting; Lange's portrait business supports the family. Throughout their marriage Dixon makes frequent sketching trips, often alone, to record the landscape and Native American life of the Southwest.

1922
Lange accompanies Dixon on a visit to Kayenta, Arizona, on the Navajo reservation.

1923
The couple travels to Chicago and New York to develop a market for Dixon's works. Extended trip to the Hopi pueblo of Walpi, Arizona, with his patron Anita Baldwin (1876–1939).

Unknown Photographer. Untitled (Dorothea Lange), 1920s. Gelatin silver print, 12.7 × 16.2 cm (5 × 6⅜ in.). Oakland Museum of California, Gift of Paul S. Taylor, A67.137.97533.

1925

First son, Daniel Rhodes Dixon, is born on May 15.

1926

Family moves to 1607 Taylor Street, San Francisco.

1928

Second son, John Eaglefeather Dixon, is born on June 12. Having been in a studio at 716 Montgomery Street for several years, Lange now moves to number 802 (Dixon has occupied a studio at number 728 since 1912).

1929

With Dixon, travels to Arizona and Inyo County, California. Stock market crashes in October.

1930–31

Family spends seven months at Ranchos de Taos, New Mexico, where Dixon works in a studio lent by Mabel Dodge Luhan (1879–1962). After returning to San Francisco, Lange and Dixon move into their respective studios in order to save money and board their children outside the city.

1932

Family spends the summer in a cabin on Baldwin's estate near Lake Tahoe. Begins to document the effects of the depression.

1933

Travels to Zion National Park in Utah and to Nevada to summer with the family. Work included in the Century of Progress International Photography Salon in Chicago.

1934

Gives up her studio and works from home (2515 Gough Street, San Francisco). Dixon goes to Boulder Dam on a painting commission from the federal Public Works of Art Project. Lange has her first exhibition, at the Oakland studio of Willard Van Dyke (1906–86). Paul Taylor (1895–1984), associate professor of economics at the University of California, Berkeley, sees the show and contacts Lange; one of her photographs runs simultaneously with his article "San Francisco and the General Strike" in the September issue of *Survey Graphic.* Second solo exhibition, at the Vallejo Street branch of the San Francisco Public Library, opens in December.

1935

In February joins Taylor's staff at the California State Emergency Relief Administration, her first documentary job. Photographs migrant workers in California and New Mexico. Roy Stryker (1893–1975) hires her for the federal Resettlement Administration (RA) in September. Marries Taylor on December 6, after their spouses obtain divorces. He has three children: Katharine, thirteen; Ross, ten; and Margot, six. The family rents a home at 2706 Virginia Street, Berkeley. For the RA, photographs in California and New Mexico. Her photographs appear in three issues of *Survey Graphic*; in

he July issue six images accompany Taylor's article "Again the Covered Wagon."

1936

In early March, at Nipomo, California, makes images of Florence Owens (1903–83) and her children while on assignment for the RA. The most famous of these photographs, *Migrant Mother* (pl. 13), is published for the first time on March 11 in the *San Francisco News*. It also appears in the September issue of *Survey Graphic* and in *U.S. Camera 1936*. A print of the image supplied by Lange is part of the U.S. Camera exhibition, held September 28–October 11 at Rockefeller Center in New York. Does summer fieldwork with Taylor, who is now with the Social Security Board. By the fall has driven more than seventeen thousand miles for the RA, traveling to Utah, Mississippi, Alabama, New Jersey, New York, Arkansas, Georgia, Pennsylvania, Indiana, Arizona, New Mexico, Texas, Oklahoma, and up and down the state of California. In October is temporarily dropped from the RA payroll.

1937

Is rehired by the RA in January to select photographs to illustrate a U.S. Senate report on migratory labor and to photograph in California, Arizona, New Mexico, Texas, Oklahoma, Arkansas, Tennessee, Louisiana, Mississippi, Georgia, South Carolina, and Florida. Laid off again by the RA (now the Farm Security Administration [FSA]) in October.

1938

Photographs in California, Arizona, New Mexico, Texas, Oklahoma, Arkansas, Tennessee, Mississippi, Georgia, and Missouri. Archibald MacLeish's book *Land of the Free*, with thirty-three images by Lange, is published. Returns to the FSA payroll in

September. Travels with Taylor to work on a documentary book. First International Photographic Exposition, New York, contains work by Lange. One photograph is published in the October issue of *Survey Graphic*.

1939

One photograph is published as the frontispiece in the March issue of *Survey Graphic*. John Steinbeck's *The Grapes of Wrath* is published in April. Spends the summer photographing with the sociologist Margaret Jarman Hagood (1907–63) in the Piedmont counties of North Carolina on a cooperative assignment from the Bureau of Agricultural Economics (BAE). For the FSA, works in North Carolina, New York, Oregon, Washington, Idaho, and California. Taylor and Lange's *An American Exodus: A Record of Human Erosion* is published.

PHOTOGRAPH BY
DOROTHEA LANGE
1163 EUCLID AVENUE
BERKELEY
CALIFORNIA
TELEPHONE LANDSCAPE 4-3880

1940

Is terminated by the FSA on January 1. Moves to 1163 Euclid Avenue, Berkeley. Works in California and Arizona for the BAE. Begins to suffer from various illnesses, including stomach ulcers. Museum of Modern Art, New York (MoMA), exhibits her work for the first time—*Migrant Mother* is included in *New Acquisitions* show. Four photographs are published in the April issue of *Survey Graphic*.

1941

Is awarded a Guggenheim Fellowship and begins to travel in Iowa, South Dakota, and Nebraska to photograph various cooperative communities. Asks for a short leave due to a family crisis in the fall. One photograph is published in the July issue of *Survey Graphic.*

1942

Is hired by the War Relocation Authority to record the process of evacuation of all persons of Japanese descent from the San Francisco area to internment camps. The September issue of *Survey Graphic* uses eight of her photographs, for the cover and to illustrate Taylor's article "Our Stakes in the Japanese Exodus."

1943 – 44

Works for the Office of War Information. Collaborates with Ansel Adams (1902–84) on a photo essay on the shipyard boomtown of Richmond, California (published in *Fortune*, February 1945, as "Richmond Took a Beating: From Civic Chaos Came Ships for War and Some Hope for the Future"). Exhibition of portraits at MoMA in 1943 includes her work; December 1943 issue of *Survey Graphic* uses four of her photographs, including one for the cover.

1945

Photographs the United Nations Conference in San Francisco for the U.S. Ministry of Foreign Affairs. Becomes too ill to work; is treated for gallbladder disease, chronic ulcers, and esophagitis and needs much home rest over the next few years.

1948

Work is included in *50 Great Photographs,* organized by MoMA shortly after Edward Steichen (1879–1973) becomes curator.

1949

Work is included in two MoMA exhibitions: *Sixty Prints by Six Women Photographers* and *The Exact Instant.*

1951

Begins to actively photograph again. In September travels to Aspen, Colorado, to participate in a photography conference, which is also attended by Adams and Beaumont and Nancy Newhall, among others.

1952

With Adams, Minor White, Barbara Morgan, the Newhalls, and others, helps to found *Aperture* magazine. "Photographing the Familiar: A Statement of Position," an article by Lange and her son Daniel, is published in the second number of that journal. Thirty-six of her pictures are included in Steichen's exhibition *Diogenes with a Camera II* at MoMA.

1953

Works on a photo essay with Adams and Daniel in Utah (published in *Life,* September 6, 1954, as "Three Mormon Towns").

1954

Works on a photo essay with Daniel in Ireland (published in *Life,* March 21, 1955, as "Irish Country People").

1955

Visits New York. MoMA exhibition *The Family of Man* includes nine examples of her work (she helped with the selection process on the West Coast the year before). In the spring begins documentation of the daily work of a public defender, focusing on Martin Pulich, a young lawyer. Begins to lease a cabin at Steep Ravine, on the coast twenty miles north of San Francisco, as a weekend and summer retreat for the family.

1956

Collaborates with Pirkle Jones (b. 1914) on a photo essay in California (published in *Aperture* in 1960 as "Death of a Valley").

1957

Teaches a seminar at the California School of Fine Arts, San Francisco.

1958

Travels with Taylor, now a consultant to the U.S. International Cooperation Administration, to Korea, Japan, China, Thailand, the Philippines, Indonesia, Vietnam, Burma, India, Nepal, Pakistan, Afghanistan, Russia, Germany, and England. Her work is included in the MoMA exhibition *Photographs from the Museum Collection.*

1959

Her photographs are included in the *Toward the New Museum of Modern Art* exhibition series at MoMA.

1960

Travels to Venezuela and Ecuador with Taylor, who is studying agrarian reform and community development for the United Nations Social Welfare Division. The San Francisco Museum of Modern Art exhibits *Death of a Valley* (also shown at the Art Institute of Chicago in 1963). Begins work on a portfolio of fifteen prints titled *The American Country Woman.* One-person exhibition of this work at the Biblioteca Communale, Milan, Italy.

1961

One-person exhibition of *The American Country Woman* at the Carl Siembab Gallery in Boston in March.

1962

Eighty-five of her works are included in MoMA's survey of FSA photographs, *The Bitter Years.* Taylor retires from the University of California. Lange joins him in Egypt in December, where he is a visiting professor at the University of Alexandria.

1963

Beginning in June, Lange travels with Taylor to Beirut, Damascus, Baghdad, Tabriz, and Tehran. In Iran she is hospitalized for malaria, then moved to a hospital in Interlaken, Switzerland, where she recovers.

1964

Begins work with John Szarkowski on a retrospective exhibition of her photographs to be held at MoMA. Completes printing and captioning for the portfolio *The American Country Woman.* Travels to Washington, D.C., and New York. Proposes independent documentary unit to record current American urban life. Her work is part of two shows at MoMA: the opening exhibition for the Edward Steichen Photography Center and *The Photographer's Eye.*

1965

Dies on October 11 in San Francisco of inoperable cancer of the esophagus. A two-part television documentary by Philip Green and Robert Katz is released.

1966

MoMA retrospective exhibition opens on January 25.

Dorothea Lange.
Full Moon, Southwestern Utah, 1953.
Gelatin silver print, 15.6 × 15.3 cm (6⅛ × 6 in.).
Gift of the John Dixon Collection, 2000.52.2.

Editor	Gregory A. Dobie
Designer	Jeffrey Cohen
Production Coordinator	Amita Molloy
Photographer	Christopher Allen Foster
Research Associate	Michael Hargraves
Printer	Gardner Lithograph
	Buena Park, California
Bindery	Roswell Bookbinding
	Phoenix, Arizona